PORTRAIT
PHOTOGRAPHY
THE ESSENTIAL BEGINNER'S GUIDE

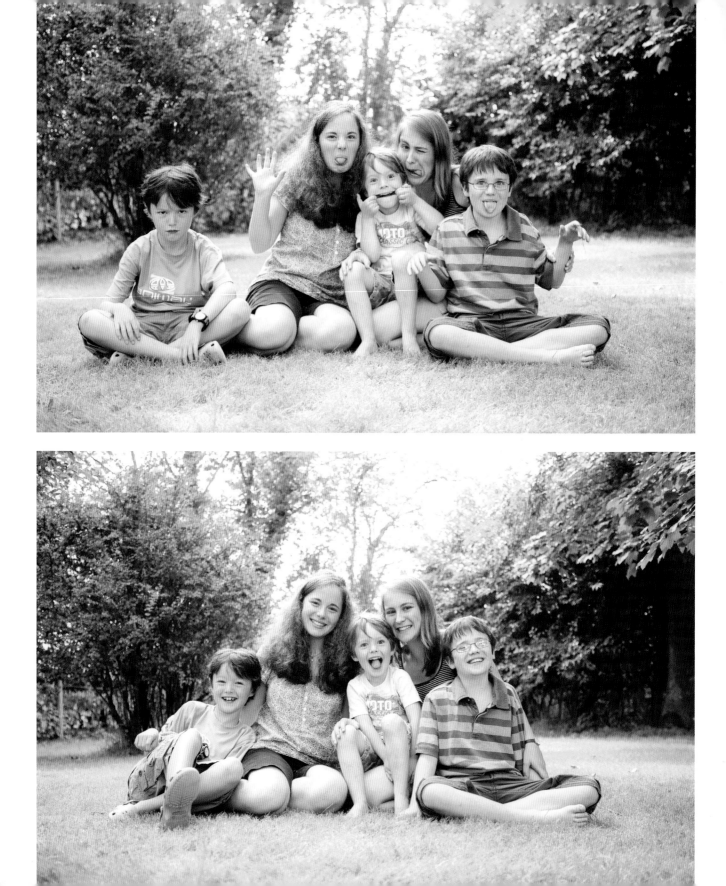

PORTRAIT
PHOTOGRAPHY
THE ESSENTIAL BEGINNER'S GUIDE

SARAH PLATER & HANNAH MACGREGOR

AMMONITE
PRESS

First published 2014 by
Ammonite Press
an imprint of AE Publications Ltd
166 High Street, Lewes, East Sussex, BN7 1XU, UK

ISBN 978-1-78145-089-5

British Library Cataloging in Publication Data: A catalog record of
this book is available from the British Library.

Editor: Chris Gatcum
Series Editor: Richard Wiles
Designer: Robin Shields

Typeface: Berthold Akzidenz Grotesk
Color reproduction by GMC Reprographics
Printed in China

Page 2: Sometimes, you have to deal with subjects who don't want to be photographed. The young boy at the left of the first shot was not in the mood to smile, so I tricked him into it, by getting the others to pull the silliest faces they could think of and shooting away. After a short while, the boy in blue couldn't resist joining in with the fun. At times like this you need to earn your smiles—you cannot demand them.

CONTENTS

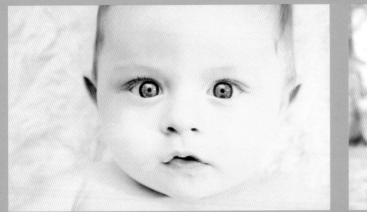

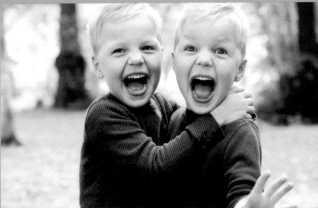

PART ONE
GETTING STARTED

When shown a great photograph, it is still a common reaction for people to say, "Wow, you have a good camera!" Yet the equipment you use is only a contributing factor. Just as you would never credit the oven for the skills of a chef, there's more than decent camera kit behind a great shot—especially when working with people.

Our formula for successful portraiture looks like this:
Camera settings + flattering light + appropriate background + good rapport = great portrait

We'll cover camera equipment and settings in Part One, followed by light and location in Part Two. Part Three will give practical advice for approaching different age groups, with hundreds of tips and techniques for getting those all-important expressions. We will also give you some practical "lessons" that you can follow for yourself to hone your skills.

Once you've read Part One, set your camera to Aperture Priority mode, select ISO 100, dial in the widest aperture available, and head outside and start shooting. Get to grips with these starter settings, taking photos of everything around you. Experiment using exposure compensation (see page 18) to lighten or darken your images, practice using different metering modes (see page 24), play around with different ways of composing your shots (see page 28), and learn to focus accurately (see page 26).

After that, move on to Part Two. Start looking for potential locations and notice how the light affects your images. Increase your ISO and try some indoor shots, but above all keep practicing!

At this stage you'll be ready to start getting other people involved, so read Part Three and arrange as many photo shoots of people of different ages as possible. Analyze your images critically—straight after you've taken them and again a few days later, with fresh eyes—and experiment with different postproduction techniques. Challenge yourself to continually improve the photos you take.

But don't stop there. Be brave and put your camera in Manual mode. Now you will be fully in control and, guess what? It's not as hard as it first appears.

Use your camera's histogram (see page 18) to tweak your settings and keep taking photos, as often as possible.

In a few days you can learn the basics.

In a few weeks you can become competent.

In a few months you will start to impress!

Let us know how you get on.

Hannah & Sarah

Left: The direct eye contact and dramatic crop in this baby portrait make for a high-impact shot. Contemporary portrait photography often features bright, uncluttered images like this one, with subtle postproduction techniques that make the colors "pop."

CHOOSING A CAMERA

You won't get far without the necessary kit, but which type of camera is best for portrait photography? There's more to it than just having a high pixel count—unless you're printing out huge enlargements of an image to go on the wall, a lot of the pixel detail will go to waste anyway. Instead, look for sensor size, lens quality, and the ability to take full control over the camera's settings.

CAMERA PHONES

Above: Camera phones are great for spontaneous shots that you want to share online, but a fixed focal length lens and tiny sensor size will limit your creativity when it comes to more "serious" portrait photographs. Image © Samsung.

Camera phones now boast huge numbers of megapixels, but don't be misled—these pixels are crammed onto tiny sensors in order to fit in amongst the phone's other electronics. This means that each pixel receives less light, so it won't necessarily produce better photos than a camera with fewer pixels, but a larger sensor. This is particularly evident in images taken in low light, which will have high levels of digital noise (random colored pixels appearing in areas that should be one solid color).

In addition, camera phones have a single, fixed lens, and the focal length is therefore not necessarily a flattering one, especially for close-ups. Many camera phones will not allow you to adjust the exposure settings, which will also curtail your creativity.

On the plus side, camera phones are portable and convenient, and as pro photographer Chase Jarvis once said: "The best camera is the one that's with you."

COMPACT CAMERAS

Above: This is a compact, or "point-and-shoot" digital camera. As the name suggests, it is small in size and therefore very portable. It is also the cheapest type of digital camera, although the vast majority do not deliver the same image quality or features as DSLRs. Image © Nikon.

In general, compact cameras have larger lenses and sensors than camera phones, which allows more light to enter, and provides a larger area for it to be recorded on. This gives them superior image quality to camera phones, while offering similar levels of portability. The image quality of some of the latest compact cameras is more than enough for the average casual snapper, but in almost all models the sensor is smaller than those used in DSLRs.

The main limitation with this type of camera is that the lens is permanently attached, so you can only use the lens that comes with the camera. A compact camera's lens may have a good zoom range, but it won't have the ability to blur out the background on a portrait in the same way that a prime lens on a DSLR camera can.

Compact cameras still can't beat DSLRs for speed either—compacts are slower to start up and focus, and slower to take a shot. Although this may only amount to fractions of a second, it can be the difference between capturing someone's expression and missing the moment.

You also need to make sure you can manually adjust the exposure settings. Some compact cameras have simplified "modes" (portraits, landscapes, sunsets, sports, and so on), but without full creative control over the exposure, your images are limited by the camera's decisions.

MIRRORLESS INTERCHANGEABLE LENS CAMERA

Above: Canon's EOS M is just one example of a MILC. It offers image quality to rival a DSLR, but in a camera body that is not much larger than a compact camera.
Image © Canon.

Mirrorless interchangeable lens cameras (or "MILCs") tend to be slightly larger than compact cameras, but as they don't contain a mirror, they are significantly smaller than DSLRs. However, they still allow you to change the lens and also have a sensor that is larger than those found in compact cameras, giving increased image quality. Indeed, some MILCs have sensors that are the same size as those in DSLRs, providing comparable image quality.

In use, the lack of a mirror system means that a MILC is much quieter than a DSLR. Many of them also function more like compact cameras than DSLRs, so they will feel more familiar to anyone who is used to a point-and-shoot camera. This makes them less daunting to budding photographers than dial- and button-covered DSLRs.

Some MILCs will accept DSLR lenses using an adapter, which is useful if you already have a range of lenses that you want to continue using. It is also beneficial because this is a relatively recent breed of digital camera, so there are currently fewer dedicated lenses to choose from.

Although the technology is rapidly improving, the autofocus system in most MILCs is not yet as good as those found in most DSLRs—some MILCs struggle to focus in low light, for example, while others fail to maintain focus on a moving subject. In portraiture, this can mean that you end up missing the moment, or the subject is out of focus.

DSLR CAMERAS

Above: DSLRs come in a wide range of builds and prices, from enthusiast models such as this one, right up to professional kit.
Image © Canon.

DSLR (Digital Single-Lens Reflex) cameras have a mirror that reflects the image coming through the lens up to a viewfinder in the camera, so you can see the precise view that the camera's sensor will record. It is this "single lens" viewing system that gives DSLR cameras their name.

DSLRs have a much larger image sensor than camera phones and almost all compact cameras. This means that each light-sensitive "photosite" on the sensor will be bigger, allowing it to capture more light. So, even though a DSLR might have a lower pixel count than a compact, that doesn't necessarily equate to lower image quality. This is particularly important when shooting in low light levels, as DSLRs will produce images containing less digital "noise" than other camera types.

DSLRs are also more flexible than compact cameras, as you can change the lens you are using. This means you can get better quality lenses that are particularly good for specific uses, such as taking portraits. As a general rule, your images will only ever be as good as the lens on the front of your camera, so being able to upgrade the lens is a major advantage over compact cameras. DSLRs also make it easier to produce images with a beautiful, out-of-focus effect that is popular in portraiture.

There are hundreds of other accessories that you can buy for a DSLR, ranging from filters that attach to the front of the lens through to external flash units for powerful, artificial lighting. Even if you decide to buy a new camera body in a few years' time, the accessories you have now should still be compatible with it. The only exception to this is if you switch brands, as the lenses for one camera system (Nikon, Canon, Sony, Olympus, and so on), won't necessarily fit on another camera system.

The disadvantages of a DSLR are related to bulk and cost. Although they vary in size, even the smallest DSLR outweighs a compact camera, making it more cumbersome. DSLRs are also more expensive than most compact cameras, especially when additional accessories are added to the cost of the camera.

Above: Professional-level DSLR cameras don't look hugely different to enthusiast models, but they typically have a higher build quality (which means they can withstand a few bumps or raindrops), larger sensors (which enable better low-light photography), and additional features, such as the ability to take more shots per second.
Image © Canon.

SENSOR SIZE

Camera manufacturers often advertise the number of pixels in their cameras far more prominently than the size of the image sensor. Yet the latter is far more important. This is because the size of the sensor determines how big each light-sensitive "photosite" on the sensor is. Each photosite records the light that generates a pixel in the final image, so larger photosites will record more light than smaller photosites. In general, this will result in a "better" picture, meaning that fewer pixels on a physically larger sensor is often preferable to a small sensor with a high pixel count.

To give you an idea of the difference, a typical camera phone's sensor measures approximately 5mm across its longest edge; a compact camera usually has a sensor measuring from 5–18mm across; and a MILC ranges from approximately 6–23mm.

The sensor in a DSLR depends on the camera's format: Micro Four Thirds cameras have sensors that are usually 17mm across; an APS-C sensor is roughly 23mm on its longest edge; and full-frame sensors measure 36 x 24mm.

The larger the sensor, the more expensive it is to produce, and the more space it takes up inside the camera. It also requires a larger lens to throw light over the whole surface, which is another reason why phone cameras are so small: a bulky lens would make them less pocketable. If you are serious about image quality, however, a larger sensor will perform better in low light, offer better depth of field control, be affected less by digital "noise" (see page 22), and offer a greater dynamic range (see page 18).

RAW OR JPEG?

All DSLR cameras and MILCs (and some high-end compacts) let you save your photographs as Raw files or JPEG files. Which you choose will often depend on your shooting style and how quickly you need the images, but it's worth appreciating the differences between them.

A JPEG is a standardized image file that has been processed by your camera. This type of file is readable by any image-editing or viewing software and is ready to print or display immediately. JPEGs are compressed when they are saved, so they take up less digital storage space than Raw files, meaning you can fit more JPEGs onto a memory card. However, some of the data from the initial exposure is lost in the compression process and more data will be lost each time the image is resaved (after editing, for example). Because of the in-camera processing, JPEGs are typically sharper than Raw files, and have higher contrast. The dynamic range is lower, though, which means detail in extremely light or dark tones can become lost more easily, as these areas turn pure white or pure black instead.

Raw files are unprocessed, which means you will need to take them into photo-editing software on your computer to

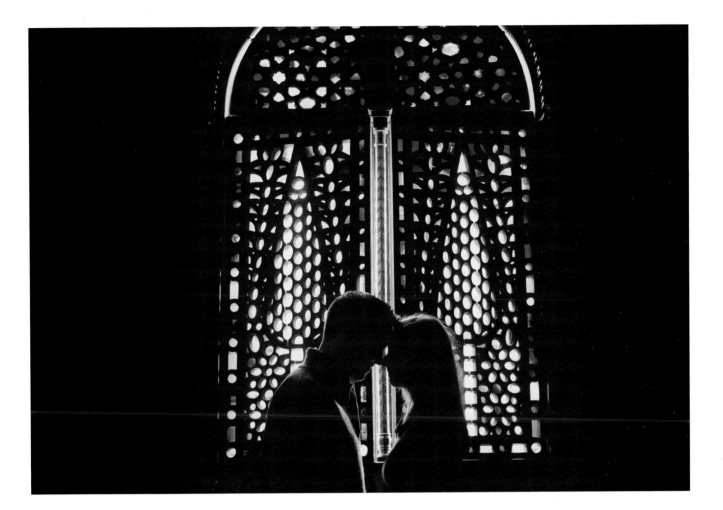

adjust sharpness, contrast, color, and many other elements, before converting them into JPEG or TIFF files that can be more easily shared or printed. Each camera manufacturer uses its own Raw files, which means you will need to check that the image-editing software you choose is compatible.

The main advantage of shooting Raw files is that they are uncompressed and contain all of the image information recorded by the camera. This allows you to make more decisions about things such as white balance at the postproduction stage, and it also means that the file will contain more detail in areas of extreme light and dark tones. Raw files are consequently much larger than JPEGs, though—on average, a single Raw file will take up the same amount of space on your memory card as two or three JPEG images.

Some cameras allow you to record both types of image at once, which means you can use the JPEGs to quickly assess your images and decide which ones to work on later (from the Raw files). As a general rule, if you are happy to spend time processing the Raw files later on, and need the maximum amount of leeway in terms of being able to adjust the image, use Raw. Otherwise, get as much as possible right in-camera and save time by shooting JPEGs.

LENSES

FOCAL LENGTH

Above: This is a 50mm prime lens. It has a fixed focal length, high-quality optics, and a wide maximum aperture setting that can produce beautifully blurred backgrounds in your portraits.
Image © Nikon.

The focal length is a number that represents the amount of magnification that a lens provides. A lens with a short focal length, such as 18mm or 24mm, has a lower magnification and a wider angle of view (these are known as wide-angle lenses). A lens with a longer focal length, such as 85mm or 200mm, has a higher magnification and a narrower angle of view (this type of lens is referred to as a telephoto lens).

In practical terms, if you use a wide-angle lens you need to stand close to your subject to fill the frame. However, standing close would result in an exaggerated perspective that distorts facial features, resulting in a comically big nose and tiny ears. Therefore, it is often better to stand further away and use a longer focal length.

For portrait photography, a focal length of 50–85mm (a mild telephoto) produces the most flattering results. The disadvantage is that you need to stand further away from your subject, especially if you want a full-length shot or to include space around your subject. Sometimes—especially when shooting indoors—this isn't always possible.

The longer the focal length, the more likely you are to see camera shake, as any slight movement while the exposure is being made will be magnified. Many lenses (and cameras) now come with built-in image stabilization to help combat this.

It is worth noting that the size of the sensor in your camera might have an apparent affect on focal length. The focal length of a lens is given in terms of 35mm or "full-frame" cameras. While the focal length never changes, if you use a lens on any camera with a smaller sensor it will produce a "cropped" or "zoomed-in" version of the same scene (the sensor is basically recording a smaller part of the scene projected by the lens). In this way a 28mm lens used on an APS-C DSLR would give approximately the same angle of view as a 45mm lens on a camera with a full-frame sensor. Therefore, wide-angle lenses effectively become "less wide" and telephoto lenses get "longer."

ZOOM VS. PRIME

Most enthusiast DSLRs come with a zoom lens included. This lens typically offers a focal length range of 18–55mm, which enables you to take a wide-angle shot (18mm), then twist the zoom ring on the lens to crop in closer without physically having to move nearer to the subject (55mm).

A prime lens has a fixed focal length and can't zoom in. This makes it a much simpler design, and the image quality only has to be optimized at a single focal length. Consequently, prime lenses usually produce higher-quality results than zoom lenses.

In order to get a blurred background on a portrait, you need a lens with a wide aperture. The aperture is represented by f-numbers, or "f/stops," and the wider the aperture, the more blurred the background will be. The widest aperture in a DSLR "kit" lens will typically be around f/3.5–f/4, whereas a 50mm enthusiast-level prime lens will have a maximum aperture of f/1.8 (or wider). You don't need to worry about what those numbers mean right now (we'll look at those later), but a prime lens with a wide aperture is very useful for portraits. This type of lens isn't very expensive, either.

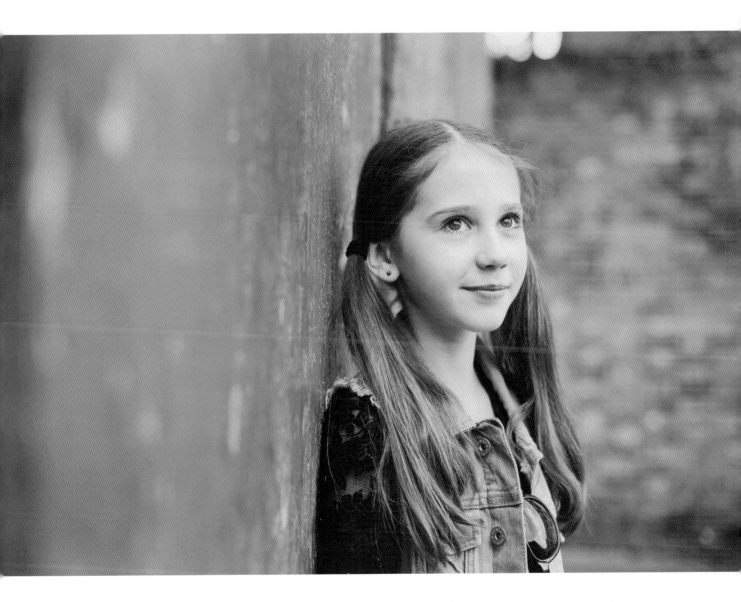

Above: This wooden garage door with peeling green paint makes a great background. A wide aperture blurs out both the door and the brick wall behind the subject, so they become abstract colors and textures.

LIGHTING

REFLECTORS

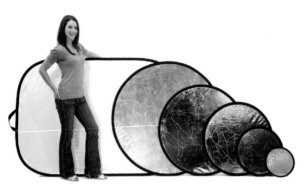

Above: Reflectors bounce light back toward your subject. Collapsible, double-sided versions offer maximum portability and flexibility. Image © Lastolite.

Reflectors are an easy and inexpensive way of throwing light onto your subject and filling in deep shadows. They come in a range of sizes and colors, but a good starting point is one that is around 3 feet (1 meter) in diameter, with white on one side and silver on the other: the white side will produce a softer, more natural looking effect, while the silver side is stronger so will boost the light more if you are working in shaded or overcast conditions. You can also get gold reflectors, which help to warm the light that's bounced back onto your subject.

If you want to save money (or accidentally leave your reflector at home), you can often improvise: a white wall, a large sheet of white card, or a large piece of aluminum foil that's been scrunched up and flattened out again will all have a similar effect to a purpose-made reflector.

DIFFUSERS

A diffuser is a thin, white fabric held taut by a foldable frame. They can be positioned between the light source and your subject in order to shield them from direct sunlight. They are ideal for use in locations where there is no naturally occurring shade, such as on a beach or in a field. Be careful when using smaller diffusers with full body shots, though, as you may be able to spot the edges of the diffuser in the image due to the sharp variation in the light falling on your subject.

You can make your own diffuser by using a thin, white piece of fabric, such as a bed sheet, but you will probably need an assistant to hold it in place, particularly if you are working outdoors.

EXTERNAL FLASH

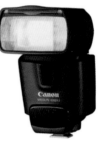

Above: An external flash is a more powerful and flexible light source than a built-in, pop-up camera flash. Image © Canon.

All DSLR cameras and MILCs, as well as some high-end compacts, have a metal hotshoe on the top that an external flash can be attached to. This type of flash typically has a fully articulated head that can be tilted and swiveled to "bounce" the light off a wall or ceiling, and it can be fitted with a diffuser, softbox, or other optional accessories to control the light. The flash can also be used away from the camera, enabling you to create similar effects to studio lighting, but with a kit that is much more portable.

STUDIO LIGHTING

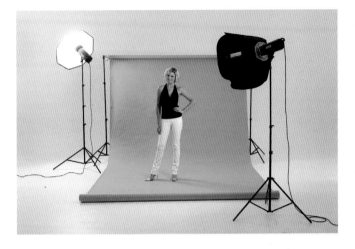

Above: The simplest studio flash kit consists of two lights with softboxes or brollies, plus a background.
Image © Lastolite.

Studio flash heads will provide you with greater power and flexibility than on-camera flash, although you are limited to working indoors unless you invest in battery packs and are prepared to carry everything around. At the very least you need one flash head, but most manufacturers offer two-light kits that include softboxes or lighting umbrellas ("brollies"). This is ideal for portraits, as these accessories soften the light dramatically.

You will also need a lightmeter to help you get the exposure right and it's worth investing in a wireless transmitter so the lights don't need to be connected to your camera. This will avoid the risk of anyone tripping over the cable and accidentally pulling your camera (or lights) over.

An alternative to studio flash is continuous lighting, which typically uses daylight-balanced fluorescent bulbs as a cool-running light source. The main advantages of continuous lighting are that you can see the effect the light is having as you adjust it, and it is also much less expensive than flash.

However, continuous lighting isn't as powerful as flash, so you will typically need to work with wider apertures, slower shutter speeds, and/or higher ISO settings. Continuous

lighting sets also don't always render colors as accurately—many are often described as "daylight balanced," but the color temperature can vary considerably.

Beyond lighting, all you really need to start shooting is a clean, white wall or a large sheet of matt black fabric to use as a backdrop. Alternatively, you might want to invest in a background support system, with a roll of plain or colored paper instead. If you do, think about how wide the paper needs to be—narrow rolls are less expensive, but you will need a wider backdrop if you intend to photograph more than one person at a time.

LIGHTING ACCESSORIES

Any accessories that you place between your subject and the light source can dramatically affect the quality of the light. Softboxes and brollies are two of the most common portrait lighting accessories.

Softboxes are available in a wide range of shapes and sizes, but the simple rule is that the larger the softbox, the softer the light. Softboxes have reflective interiors that bounce the light inside, with layers of diffusion material at the front to further soften the light. They produce a very flattering effect for portraits.

The alternative to a softbox is an umbrella (or "brolly"), and these are also available in a range of sizes. There are two types of lighting umbrella—shoot-through and reflective. A shoot-through brolly is made of a thin, diffusing fabric, and is used with the light aimed at the subject. The light passes through the umbrella, which diffuses it before it reaches the subject.

Reflective umbrellas are used with the light facing away from the subject, to bounce light back toward them. Reflective umbrellas are available with white (softer) and silver (harsher) linings.

Above: When you are shooting in areas of dappled sunlight, make sure that sun spots don't fall on your subject's face as this may result in harsh shadows and squinting. In this shot, the sun spots appear as lovely, out-of-focus highlights in the background.

OTHER ACCESSORIES

MEMORY CARDS

Memory cards are used to store your photographs in-camera as you shoot them. There are several different types, so you will need to check which type your camera is compatible with—the two most common types are Secure Digital (SD) and CompactFlash (CF). Once you know this, you have two more decisions to make: which size (capacity) of card to get, and what data transfer speed you want or need. The simple rule here is that the larger the capacity and the faster the speed, the more expensive the memory card will be.

TRIPOD

A tripod is useful when shooting in low-light levels, as it helps prevent camera shake (see page 21). However, your subject will also need to stay still throughout the exposure, otherwise they may become blurred.

Tripods can be unwieldy to carry, so if you're on location and need to stabilize your camera you may want to try leaning on the back of a chair, or against a wall or door-frame. When you're outdoors, changing your stance and using both hands to steady the camera can help as well. Alternatively, crouch down and support one of your elbows on your knee. Lenses and cameras with image stabilization can also reduce the need for a tripod.

SOFTWARE

To process Raw files or edit JPEGs you will need to undertake some level of postproduction, which makes image-editing software an essential consideration. The most well-known software comes from Adobe, which offers a number of editing programs, including:

Adobe Photoshop Elements: An easy-to-use software package that offers enthusiast-level image editing.
Adobe Lightroom: Image-editing and organization software aimed at amateur and professional photographers.

Adobe Photoshop: Adobe's top-end editing software. Adobe Photoshop CC is a new subscription-based model, but older versions are available for a one-off payment. However, you will need to check compatibility with your camera's Raw files, particularly if the camera is very new.

All of Adobe's products are available for both Mac and Windows users, and you can download trial versions at www.photoshop.com. However, lower cost alternatives exist, and there are even free options that you might want to consider. Due to the pace of change in software, it's well worth searching online to get the latest information and recommendations, but current options include:

GIMP: The GNU Image Manipulation Program is a free, open-source image-editing program that offers a similar set of features to Photoshop. The program is maintained and updated by volunteer developers. Visit www.gimp.org to find out more.
iPiccy: iPiccy offers one-click image editing for free. Everything is done online (www.ipiccy.com) and the tools are simplified to make them beginner-friendly.
PicMonkey: This site (www.picmonkey.com) offers a limited range of free tools that are subsidized by advertising. There's also a subscription option that will allow you to get access to the full range of tools.
Google+: Google has created free tools to edit, organize, and share photos, but you will need to install and use the Google Chrome web browser to access them.

EXPOSURE

An exposure is made each time light is collected on your camera's sensor to create an image. The combination of aperture, shutter speed, and ISO determines whether the exposure is correct or not. If too much light reaches the camera's sensor, the image will be "overexposed" and appear washed out; if there is insufficient light, the image will be "underexposed" and look too dark.

HISTOGRAMS

A histogram is a useful tool for checking whether your shot needs more or less light. Most DSLR cameras and MILCs have the ability to display a histogram over or next to each image once you've taken it. This is a visual graph showing how many pixels there are of each of the bright, mid, and dark tones. As you practice taking more and more portraits, you will start to recognize whether the spread of pixels on the histogram is the right shape for what you are trying to achieve. For example, a portrait taken indoors, in front of a dark background, will produce a histogram with a very different shape to a portrait taken outdoors on a sunny day. The more contrast there is in an image, the more spread out the pixels will be; with low-contrast images, most of the pixels will be grouped in one area of the graph.

EXPOSURE COMPENSATION

When the camera is choosing any of the exposure parameters itself, there's always a chance that it will not get it right (after all, it cannot know your intentions). When this happens, exposure compensation is a quick and easy way to tweak the settings for the next shot.

If the histogram has pixels stacked at the left edge, it means the darkest areas of the image will just be captured as pure black. If the histogram has pixels stacked at the right edge, the lightest areas of the image will be captured as pure white. On most cameras you can use exposure compensation to fix this problem.

Hold down your camera's exposure compensation button and turn the dial to a positive value to increase the exposure (making the image lighter) or select a negative value to reduce the exposure (making the image darker).

Alternatively, you can change your aperture, shutter speed, and ISO setting—these will be explained in more detail over the following pages.

HIGH CONTRAST

Light is measured in "stops," with an average daylight scene covering a range of around 10 stops from the darkest to brightest areas (assuming the sun isn't in shot). This is known as the "dynamic range," which varies depending on the level of contrast in a scene. Dynamic range decreases on overcast days, for example, while it increases with high-contrast scenes (perhaps when your subject is backlit).

The human eye can process, or "see," a dynamic range of about 20 stops, but most DSLRs can only capture around 10–13 stops (and compact cameras less than that). This is important to understand when you are faced with a high-contrast scene.

Imagine, for example, a couple on their wedding day, with the bride wearing a white dress and the groom dressed in a black suit. If the difference between the whitest part of the dress and the darkest shadow exceeds the camera's dynamic range, the camera will be unable to record detail in both areas in a single shot. Instead, one (or both) of these areas will be recorded as pure white or pure black.

In this situation, the histogram will often have stacks of pixels at one or both ends of the graph, indicating that detail has been lost. When this happens you can either take two different exposures (one for the shadows and one for the highlights), and combine them using photo-editing software, or accept that you will have to lose detail at one end of the scale.

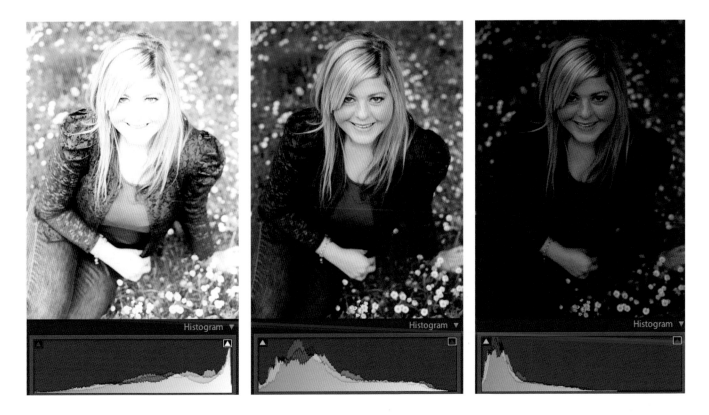

OVEREXPOSED CORRECTLY EXPOSED UNDEREXPOSED

HISTOGRAMS & EXPOSURE

Too much light has resulted in overexposure in the first photograph (above left), with washed-out colors and lost detail in the lightest parts of the image. The histogram shows a high number of pixels stacked at the right side, which indicates that some areas have been recorded as pure white.

The second shot (above center) has been exposed correctly. The histogram has more pixels toward the left side of the graph, which reflects the amount of darker tones in the shot, such as the subject's clothes and the dark grass in the background.

Too little light has caused an underexposed image (above right), with muddy colors. The histogram has a complete absence of pixels at the right side of the graph, indicating a lack of highlights in the shot.

APERTURE

If the camera's lens is like a human eyeball, then the aperture is the pupil—it can expand or contract to let more or less light through to the camera's sensor. When taking photographs in darker conditions, you can compensate for the lower light levels by opening the aperture wider and allowing more light through.

The trade-off from this is that a narrower band of the image appears sharp. However, this "shallow depth of field" technique is often used in portrait photography to intentionally throw the background out of focus and concentrate attention on the subject.

Blurring the background will instantly set your photos apart from snapshots where cluttered areas of the image detract from the subject. With just your subject's face or eyes sharply focused, the viewer is drawn to their expression. As this technique enables more light to reach the sensor, you can also use it to take photographs in low-light conditions without getting unintentional blur from camera shake.

One thing that takes a little getting used to is how the aperture setting is expressed. A wide aperture, which allows more light in, has a lower "f-number" (f/2.8 or f/4, for example). Conversely, a small aperture, which lets less light through and will result in more of the image being in focus, has a higher f-number (f/18 or f/22, for example). A shallow depth of field is therefore a result of a wider aperture and a lower f-number.

To set the aperture (and let the camera choose the shutter speed), select Aperture Priority on the camera's mode dial. On most cameras this is marked as "A."

Above: The first shot (above left) was taken using a small aperture setting of f/18. This has meant that the subject and the background behind are both in sharp focus. By comparison, using a wide aperture (f/2.8) means that the subject is in focus, but the background is blurred (above right). To increase this effect you can move the subject further away from the background.

MAXIMUM APERTURE

Not all lenses are created equal. Low-cost zoom lenses aimed at amateur photographers tend to have restricted aperture settings, particularly at the wider end. To get a similar effect as having a wide aperture, step back from your subject and zoom in to a focal length of between 50mm and 85mm. Make sure your subject is a few feet away from the background if you want the latter to be out of focus.

SHUTTER SPEED

The shutter speed is the length of time that the shutter is open for, allowing light through to the camera's sensor. The standard shutter speed range is 1 sec., 1/2 sec., 1/4 sec., 1/8 sec., 1/15 sec., 1/30 sec., 1/60 sec., 1/125 sec., 1/250 sec., 1/500 sec., and 1/1,000 sec., although most cameras now offer both longer and shorter speeds. Using Manual exposure mode, it is also possible to make exposures lasting several minutes (or even hours) with some cameras.

Each adjustment up or down the scale will halve or double the length of time the shutter is open. In combination with the aperture and ISO settings, the shutter speed determines how much light reaches the sensor in order to make an exposure.

If you are photographing someone in bright conditions, a fast shutter speed will prevent too much light from reaching the sensor. For example, if you want to use a wide aperture on a bright day, you will also need to use a fast shutter speed, otherwise the image will be overexposed.

A fast shutter speed will also freeze motion—if you are taking a shot of a child running toward you, a shutter speed of 1/250 sec. will be quick enough that their legs will be sharp, rather than just a blur. On the other hand, if you wish to show motion, a slower shutter speed will record any movement that occurs during the exposure as a blur.

A longer shutter speed is also useful when taking portraits in lower light levels or when you want to use a smaller aperture, as it allows more light in. There is, however, a trade-off: the longer the shutter is open for, the more likely it is that camera shake will affect your image. This occurs due to tiny camera movements made by the photographer while the shutter is open, causing the whole image to be blurred.

As a general rule, to avoid camera shake (when you are handholding your camera), the shutter speed you use should be equal to or higher than the focal length of your lens. For example, if you are using a 50mm lens, make sure your shutter speed is at least 1/50 sec., if you are using a 100mm lens, it should be at least 1/100 sec., and so on. Any slower and camera shake is more likely.

If you want to choose the shutter speed (and have the camera select the correct aperture), select Shutter Priority from the camera's mode dial. On most cameras this is marked as "S," although Canon cameras use "Tv" (for "Time Value") instead.

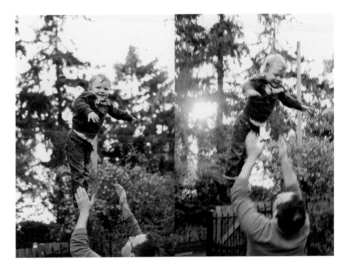

Above: A fast shutter speed freezes moving subjects mid-motion. This is ideal for bright conditions and when you don't want to record any blur on a moving subject, such as this toddler in mid-flight (above left). However, using a slow shutter speed records movement as a blur, which is much better for creating a sense of motion, but risks camera shake (above right).

ISO

ISO is the name given to the standardized measure of a camera's sensitivity to light. It is the third of the three elements that determine the exposure, the other two being the aperture and shutter speed. While the aperture controls how much light comes through the lens, and the shutter speed determines how long the sensor is exposed for, the ISO sets the sensitivity of the camera's sensor, determining how much light is needed to start with.

A typical range of ISO settings would be 100, 200, 400, 800, 1600, and 3200 (with one or two steps in between). Many cameras now go much higher. The lower the ISO setting, the less sensitive the sensor is, so the more light is required to make an exposure. Doubling the ISO setting—from ISO 100 to 200, for example—doubles the sensitivity.

However, there is again a trade-off: when the ISO is raised, it increases the risk that the image quality will be reduced due to "noise." Noise is present in all electronic devices that transmit signals, and in a digital photograph it can be thought of as the visual equivalent of the background hiss that a radio emits when it's at full volume. When you ramp up the ISO, you amplify this noise, which can result in specks of random color in areas of the image that should be a single color. Noise tends to be particularly evident in darker areas of a photograph.

Cameras with larger sensors (and bigger pixels), such as DSLRs and MILCs, are less affected by noise than compact cameras and camera phones, and constant improvements in technology mean that less noise is created in newer cameras. Image-processing systems are also getting better at removing it when it does occur, both in-camera and by using image-editing software.

CHOOSING THE ISO SETTING

If you are taking a portrait outdoors on a bright day, select a low ISO setting to ensure you get the highest image quality. If you are shooting under lower light levels, such as indoors, raise the ISO so you can keep using the same aperture and shutter speed settings as you would outside. If you need to, you can use a wider aperture or a slower shutter speed (as well as increasing the ISO) when shooting in dark conditions—all will result in more light contributing toward the exposure.

When using Aperture Priority mode or Shutter Priority mode, you will also need to set the ISO: to change the setting on most DSLRs, simply hold the ISO button and turn the main control dial.

Right Top: On a bright day outdoors, you can use a low ISO setting of 100 or 200 and still have plenty of light to create a good exposure. Lower ISO settings mean higher quality images with less digital "noise."

Right Bottom: This shot was taken indoors, a little way away from a window. I needed to set the ISO to 1000 to get a good exposure, but this has resulted in visible digital "noise" in areas that should be one, pure color.

EXPOSURE METERING

Cameras have built-in exposure metering systems that are designed to measure the amount of light reflected from your subject to determine the exposure needed. However, the camera doesn't know what you are trying to achieve from each photograph, so it is programmed to assume that the tones in every scene would average out to mid-gray.

Most of the time, this system works, but problems occur when you photograph subjects that are much brighter or darker than this "average" target: a bride in a pure white wedding dress, for example. The camera will try and compensate for all the light reflected off the dress, making it a mid-gray. This means the shot will be underexposed (too dark). Equally, if you are photographing a dark subject in front of a very dark background, the camera will overexpose the image as it tries to average out the tones. As a result, the shot will be overexposed (too light).

METERING PATTERNS

Most cameras offer multiple metering patterns that allow your camera to "read" the light in a scene in different ways. The main metering modes are:

Multi-zone metering: Also known as Evaluative (Canon), Matrix (Nikon), and Multi-segment (Sony) metering, a multi-zone metering pattern takes light readings from multiple areas across the frame. It selects the exposure based on an average of all those areas, usually with a slight bias toward the focus point. This setting is effective most of the time, but can fail when the subject is very light or dark; when the scene has high levels of contrast; or when the subject is backlit. In these situations you will need to use exposure compensation or an alternative metering pattern.

Center-weighted metering: When you select this metering pattern, the camera takes a reading from the frame as a whole, but biases the exposure toward the

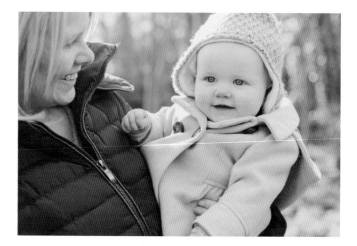

Above: With a scene like this, which has a fairly even spread of light and dark tones, most cameras will do a good job of metering correctly using a multi-zone metering pattern.

central area. This metering mode was the default setting for most cameras until multi-zone metering was introduced.

Spot metering: The exposure is based on a light reading from a small area of the frame, ignoring all other areas entirely. When using spot metering you need to ensure that the area you meter from is a midtone, otherwise the camera will under- or overexpose the photograph.

EXPOSURE LOCK

Most DSLRs and MILCs have an automatic exposure lock feature that will "hold" your exposure settings when you press and hold the shutter-release button down halfway. This is useful for shots where your subject is off-center or is much lighter or darker than the rest of your shot.

It is normally used with spot metering or center-weighted metering: the idea is to position the metering area over the part of the image you want to expose for and press the shutter-release button down halfway to take an exposure reading. Keep the shutter-release button half pressed and reframe your image to achieve

Above: In this shot, a dark background surrounds a small, pale-skinned subject. The camera's multi-zone metering pattern would probably overcompensate for all the dark tones and overexpose the shot, but center-weighted metering would prioritize the tones at the center of the frame.

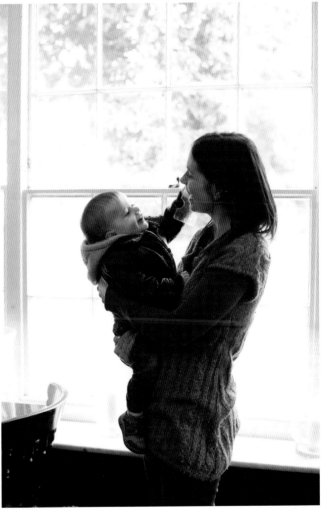

Above: This shot contains bright backlighting, which might fool a camera into underexposing. Using spot metering allows you to take an accurate exposure reading from the subject's face.

your desired composition. Press the shutter-release button down fully to take your shot. The majority of DSLRs and MILCs also have an AE−L (Automatic Exposure Lock) button that can be used to lock the exposure while you reframe your shot.

FOCUSING

Your camera doesn't know the specific nature of the photograph you are trying to take, so by default it will usually focus on whatever is at the center of the frame or closest to the camera. This means that if your subject is off-center, or part of a complex composition, the camera's autofocus may focus on another area of the frame instead, leaving your subject blurred.

Some cameras now have automatic face detection, which can help give priority to focusing on people's faces, but the camera may focus on the nose, lips, or ears, when what you normally want is for the eyes to be sharp. This is most important when you're shooting close-ups and/or using a wide aperture.

Most DSLRs have a number of focus areas (known as focus points), which you can manually select if the camera is focusing on the wrong part of the scene. Alternatively, if you set the central focus point you can move the camera so the subject is at the center of the frame, press the shutter-release button down halfway to focus, and keep the button pressed as you reframe your shot. Then, when you are ready, press the shutter-release button fully to make your exposure.

DEPTH OF FIELD

Depth of field is the amount of an image in front of and behind the point of focus that also appears sharp. When shooting with a wide aperture (f/2.8 or f/4, for example), the depth of field is shallow, so only things that are at the same distance from the camera as the focus point will appear sharp.

If you used the same wide aperture setting for two different shots of a family of five, you would be able to get completely different results depending on where you place people relative to the focus plane. If you ask them to stand side-by-side, shoulder-to-shoulder, and take the picture parallel to the line-up, then everyone's face will be sharp

(as long as you focus correctly), while the foreground and/or background will be out of focus.

However, if you placed each member of the family in a line, one behind the other, and took the photo from in front of the first person, the person you focus on will be much sharper than the others. Everyone else would be more blurred the further away they are from the person you focused on. To get more people in focus, you would need to use a smaller aperture, such as f/11 or f/16, which will produce a larger depth of field.

Above: When shooting with a very wide aperture, you will have a shallow depth of field, so only a small amount of the scene will appear to be in focus. This makes accurate focusing especially important. In the first shot (above left), the subject's ears are sharp, but his eyes are slightly blurred. Selecting a focus point that is on your subject's eyes will tell the camera to focus sharply on this area instead (above right).

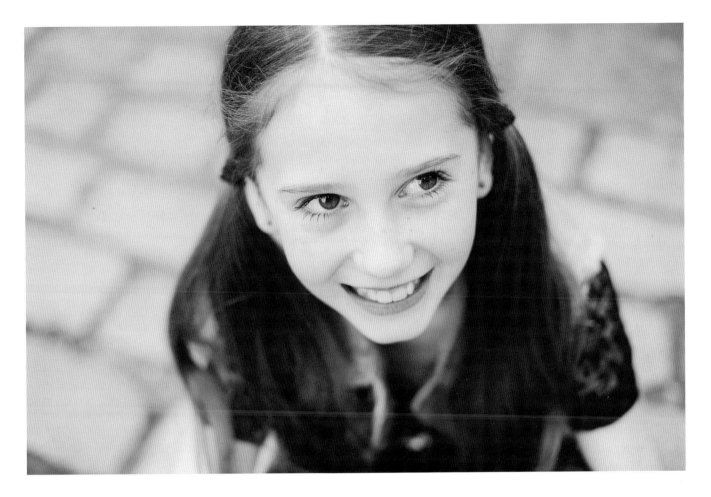

Above: Your subject's eyes should be sharp, even if the rest of the image is not. The wide aperture used here to blur the background of the shot meant it was especially important to focus accurately.

MOVING SUBJECTS

If your subject is moving, it can sometimes be out of focus by the time you take your shot. In a situation like this, choose the distance you want to take the shot at and pre-focus at that point before the subject starts moving. You can do this by focusing on an object that is at the same distance and holding the shutter-release button down halfway to lock the focus. When your subject reaches the correct point, you push the shutter-release button down fully to take your shot.

MANUAL FOCUS

On most DSLRs and MILCs you can flick a switch to change from automatic to manual focus. In manual focus (MF) mode, you need to turn the focusing ring on the lens until the subject looks sharp through the viewfinder. This isn't always as quick as using your camera's autofocus, but in certain situations it can be more accurate.

COMPOSITION

Your eye doesn't take in an entire photograph the very instant you look at it. Instead, it travels around its components to make sense of it—the way those components are arranged is called the "composition."

Careful composition will make your images more visually appealing and give them greater impact. It will also change where the emphasis of the portrait is—whether it's on the subject's eyes, or the relationship between two subjects, for example.

For portraits, the position of the subject within the frame is particularly important, and this starts with deciding which way round to take the image. A "portrait" orientation is longest on the vertical axis, whereas a "landscape" orientation is longest on its horizontal axis. Despite their names, both are valid orientations for portrait photographs—some portrait photographers use a landscape orientation almost exclusively.

Other things to consider include the camera angle, framing, lines, eye contact, balance, and whether to apply (or ignore) compositional "rules," such as the rule of thirds.

RULE OF THIRDS
The rule of thirds is one of several traditional "rules" of composition. Imagine two evenly spaced horizontal lines drawn across the frame, crossed by two evenly spaced vertical lines. The rule of thirds says that to create a strong composition, a key part of a shot (often the subject's eyes in a portrait) should be placed where two of those imaginary lines intersect. However, while this can be effective, if you always follow this rule your shots will become monotonous.

BALANCE
If there are more image elements at one side of the frame than the other, it can look unbalanced and less appealing. Imagine subjects, backgrounds, and foregrounds as "visual weight" and check that this weight is spread across the frame to give an overall sense of balance, rather than having one part of the image much "heavier" than the rest.

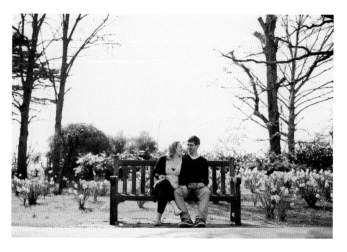

Above: The centered couple are perfectly balanced by the trees and flowers at either side of this shot.

EYE CONTACT
Eye contact has a powerful impact on the viewer, as it catches and holds their attention. However, a whole set of images with direct eye contact would be repetitive. Instead, have your subject look straight down the lens in some shots, then away from the camera in others.

Off-camera gazes often work best with more moody, thoughtful shots as they have a greater air of mystery and intrigue. These kinds of shots are also great for candid portraits, where the photographer is recording events as they unfold, rather than choreographing everyone. In shots where your subject is looking away, leave space in the frame on the side their gaze falls, otherwise the viewer's eye will be led out of the frame.

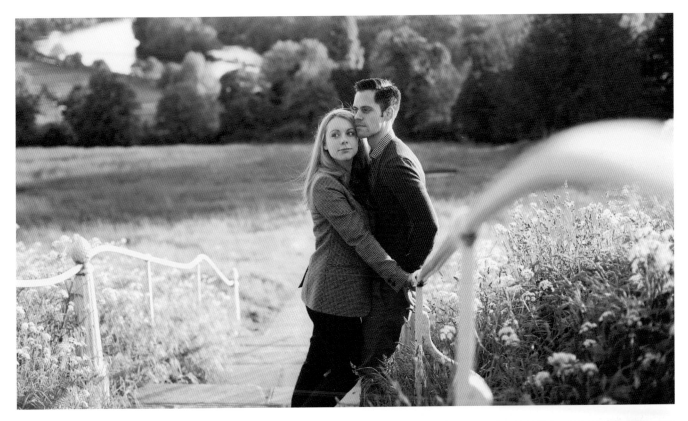

Above: Positioning the camera next to the handrail resulted in a strong composition that draws your eye toward the couple at the center.

LINES

Compositional lines can include a patterned sidewalk or wall behind your subject, while lead-in lines are elements such as a handrail or curb that draws the viewer's eye toward your subject.

Lines that are at an angle—particularly diagonals—add energy to a composition. Wherever possible, arrange your subject or angle your camera to tilt background lines so they run corner-to-corner instead of edge-to-edge inside the frame.

You can also experiment with lead-in lines to strengthen a composition. For example, you could include the winding path a couple are walking along, or use two converging lines of trees to draw the viewer's eye toward a subject positioned between them.

Above: Use an element from your location to frame your subject. Here, the winding branches of the tree and its colorful dots of blossom surround the couple, while keeping their faces unobstructed.

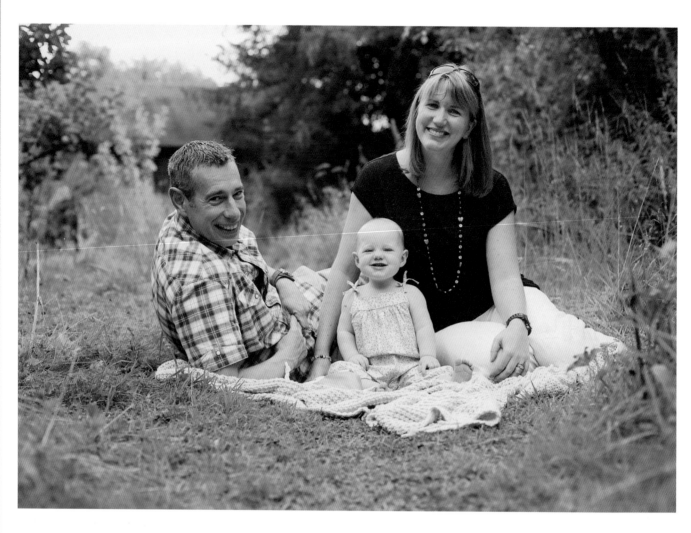

ANGLE

Change your viewpoint to add variety and make a statement about your subject. For example, shooting from above your subject's eye level implies vulnerability, while shooting upward from below their eye level implies confidence, power, and even arrogance. Lie down on the floor or use steps to make your angle more extreme.

If you're looking to flatter your subject, there's one winning angle that flatters almost everybody—shoot from about 45 degrees above your subject's eye level, with their body facing slightly away from the camera. Get them to look up to the lens and you will find that this opens their eyes to their widest and helps to conceal any double chins.

Above & Right: The first image (above) was taken with the camera at the subjects' eye-level. Changing the orientation of the camera (from landscape to portrait) and shooting from ground level created a completely different look (right).

FRAMING

Use image elements to frame a subject. You could shoot within a doorway of a room, through the window of a car, or through some blurred-out foliage, for example. This gives added foreground or background interest and can boost compositional impact.

CROPPING

Cropping is the act of removing unwanted elements from the frame in order to improve the composition or accentuate a certain aspect of the image. You can do this by zooming in, moving closer to your subject, or by using image-editing software.

You need to judge how much space to leave around your subject in each shot you take: you may want to crop in extremely close to emphasize his or her eyes, or place them small in the frame to imply vulnerability, for example. You may want to exclude background distractions by cropping in close to your subject, or you may want to show the subject in his or her environment.

Where you crop into a subject's body is also important, as it can look unusual if you cut off certain elements and not others. Standard crops include:

Full length: The whole body of the subject is visible.

Three quarter length: The bottom of the frame crops into the subject's thighs, with the rest of their body visible.

Bust shot: The bottom of the frame crops into the subject's waist, with their upper torso and head visible.

Crop shot/close-up: The top of the frame crops into the top of the subject's head, with their face, chin, and part of the neck visible.

Regularly changing your crop during each shoot will make your final set of images look different, even if the subject is wearing the same clothes and is in the same location. Even the same pose can look very different depending on the crop; you could start with a wide shot of the subject with plenty of the background, then zoom or move in closer to take a full length with less background visible, then a shot with just their torso and head, and finally a close-up. As well as portrait and landscape orientations, you could also crop your images into panoramic or square shapes using photo-editing software for added variety.

POSTPRODUCTION

It is likely that you will need to spend time tweaking your shots on a computer after taking them, but you can save a lot of time and effort by getting as much as possible right in-camera (exposure, white balance, and so on). This will allow you to use your editing time to do things your camera cannot, such as running a series of actions to give a photograph a certain style.

In addition, aim for quality over quantity when shooting. Although it's cheap and easy to take hundreds of photographs, the task of narrowing them down afterward can quickly become disheartening. Check and delete shots as you go, analyzing each one for potential improvements before deciding whether to keep it or not.

There are many software programs available and there is an infinite amount of edits that you can make to an image. However, as a general rule, your edits should subtly enhance each portrait, rather than make them appear obviously retouched. There are some very powerful tools out there, but there are some equally bad ones, so show some restraint! Although you want your shots to look impressive, they should also look believable.

ACTIONS
One of the easiest ways to edit a series of shots in a consistent way is to use "actions." These are a series of tweaks that give the image a certain look and feel. Some of these are freely available on the Internet, while others come at a cost. Each of the elements that is used to create an action can usually be adjusted individually if required.

BLEMISHES
If your subject has blemishes, use the "two week rule." If the blemish won't be there in two weeks' time (a spot, scratch, or speck of sleep dust, for example), then most people would prefer that you remove it in postproduction. For other, permanent features (such as a mole, freckle, or birthmark), you risk offending your subject by editing it out—so leave it unless your subject specifically requests its removal.

COMMON EDITS
There are certain editing tasks that you will find yourself performing again and again, such as cropping, converting to black and white, and boosting colors to make them more intense and high impact. Some of these processes are described in this section, along with the unedited shots that demonstrate just how important postproduction can be. These examples show just a few of the most popular software packages that are available to you in action.

EASY TWEAKS (PICMONKEY)

1 The unedited shot.

2 PicMonkey has an **Auto adjust** button for changing image colors, or you can use sliders to adjust the warmth and saturation of an image.

3 Use sliders to tweak the **Brightness**, **Highlights**, **Shadows**, and **Contrast** of your image, or use the **Auto adjust** button.

4 A series of actions is available, providing you with one-click effects that can give your image a particular look and feel.

EASY TWEAKS (iPICCY)

1 This is the image as it looked when it came out of the camera.

2 iPiccy allows you to correct colors using an **Auto Colors** button, or you can use the **Neutral Picker** and click on an area of the image that should be gray or white—the software will correct the colors using that part of the image as a guide.

3 There is also a choice of preset actions that you can apply to each shot, modifying the extent to which they affect the image. This shows a **Vintage** effect at 100% strength.

4 Masks can be used to restrict iPiccy's actions to certain areas of the image. By "painting" across parts of a shot you can decide which areas you want to be affected (or not).

COLOR ADJUSTMENTS (PHOTOSHOP)

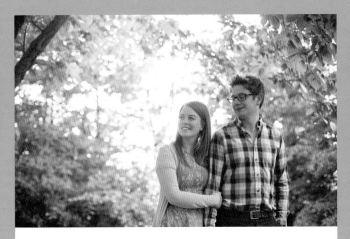

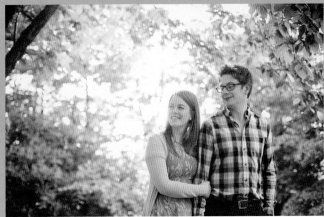

1 This is the unedited shot, straight from the camera.

2 I tidied up the couple's skin and increased the saturation of the purple flowers. Then I used an action to warm the shot and add "creaminess" to the skin tones.

BLACK AND WHITE (PHOTOSHOP)

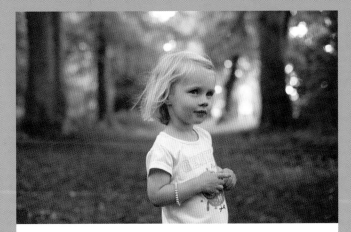

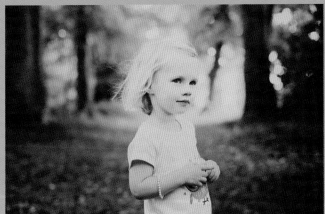

1 The unedited image lacked impact, so I boosted the contrast using Photoshop's **Curves** tool.

2 I converted the image into black and white, then cropped the shot to place the girl at the center of the frame.

FLARE (PHOTOSHOP)

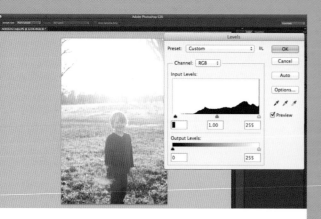

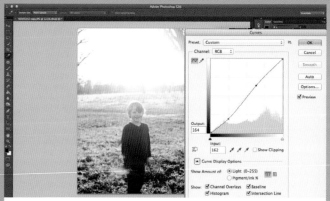

1 With the sun's rays included in the frame, the extreme lens flare has meant that the dark tones on the boy's trousers have been reduced to muddy grays and browns instead of blacks. After opening the shot in Photoshop, I used **Levels** to bring back the black tones.

2 I opened the **Curves** dialog and gave the diagonal line a slight "S" shape to add depth and contrast to the shot.

3 There were some distracting branches at the left side of the image, so I selected them and removed them from the shot to tidy it up.

4 I ran an action on the shot—the elements that make up the action can be seen (and adjusted) using the tools at the right of the screen.

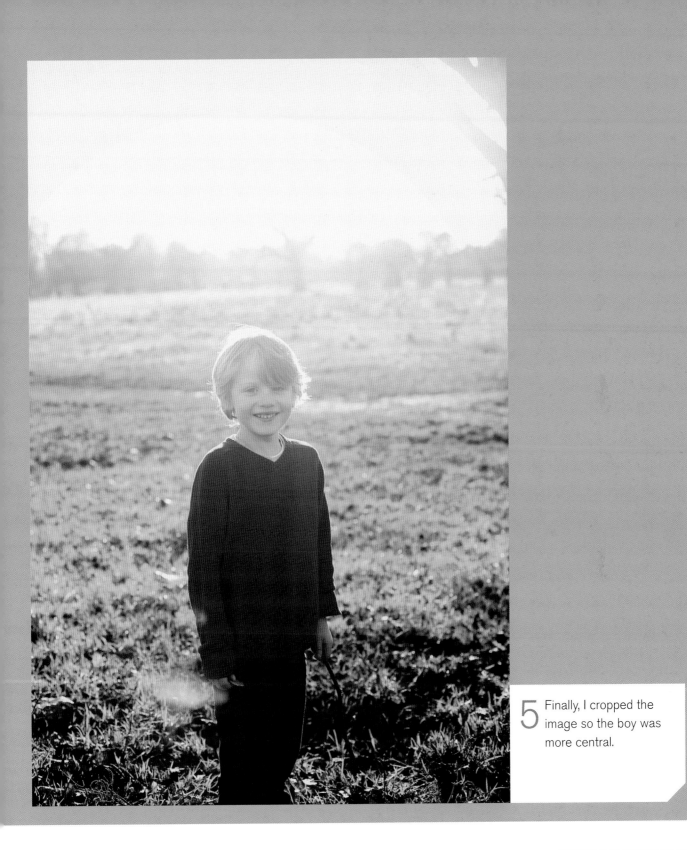

5 Finally, I cropped the image so the boy was more central.

PART TWO
LIGHT & LOCATION

As you become familiar with your camera's controls, you'll be able to adjust them intuitively, leaving you to concentrate on the location and lighting.

Sometimes, you may not have much choice regarding the location of your photo shoot—on a rainy day you may be restricted to staying indoors, for example, or find yourself limited to a single room when photographing a newborn baby. At other times you may be photographing older subjects who are able to move from location to location as you scout out potential backgrounds spontaneously.

If you have a particular style of image in mind, you will need to consider the types of location that will suit that style—urban settings often suit teenagers well, whereas couples may prefer to go somewhere more discreet, such as a park or woodland.

For some shots you may want to use a professional studio background in black or white, so the emphasis is on your subject. If you're on a budget, you can recreate this effect using a plain white wall or a large piece of dark, matt fabric.

Alternatively, you might want the background to add to the story told by the image, by positioning your subject in an environment that holds a lot of meaning for them—a bedroom, workshop, or favorite retreat, for example.

Whatever location you choose, the lighting will make or break your images. The most stunning setting won't work if there isn't enough light to make a decent exposure. Equally, overly strong light (such as direct sunlight)

won't work either. Most of the time you will be able to manipulate the light by turning down the flash power, using a reflector, holding up a diffuser, or repositioning your subject, but sometimes you will need to head somewhere else, or schedule the shoot for a specific time of day.

As a rule, if you can't find a way to make the exposure work, always prioritize light over location.

Left: In photography, light and location are inextricably linked. The same location can look vastly different as the light changes throughout the day. In turn, the choice of location dictates your options regarding the light. Is there a shaded area? Can you move your subject so the light falls on them from a different angle? Is there sufficient light?

LIGHT PROPERTIES

Photography literally means "writing with light," so understanding how to manipulate natural and artificial lighting is one of the most important skills in portrait photography. A studio light diffused by a large softbox will produce an image with a completely different look and feel to a shot taken outdoors just as the sun is setting, so mastering a range of lighting skills will give you the ability to produce diverse, high-impact shots in any situation.

THE DIRECTION OF LIGHT

The angle at which light falls onto your subject will affect the extent and position of any shadows. Some shadows can flatter, as they slim the subject's face and give the image a sense of depth and drama, while others can appear unsightly. Shadows are caused by directional lighting, such as strong sunlight and artificial light that is stronger on one part of the subject than the rest.

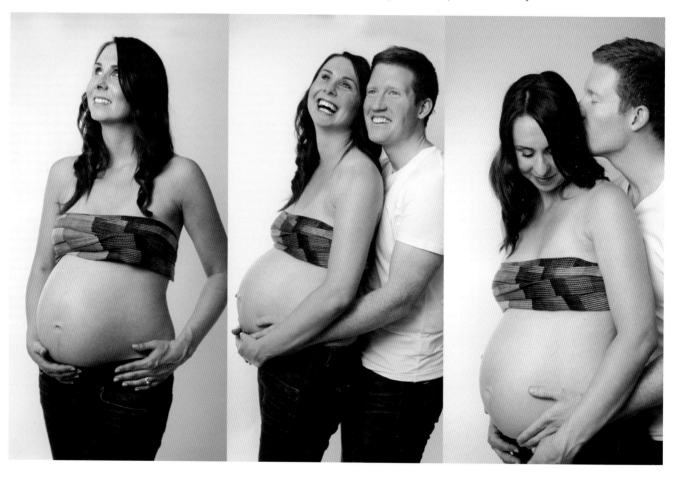

Above: This series of shots was taken using studio lights and colored background paper. Artificial lighting is far more controllable and consistent than natural light, and is great when the weather cannot be relied upon!

Flat lighting is the opposite of directional lighting. Here, light falls evenly across the subject, smoothing skin tones and making any blemishes less obvious. Flat lighting includes top shade, cloud cover, and "high key" artificial lighting.

When using artificial light sources, such as studio flash, you will have full control over the positioning of the lights. However, when using natural light, you will need to choose your locations carefully and position your subject to make the most of the light available to you. You can also use aids such as reflectors and diffusers to manipulate the light.

THE COLOR OF LIGHT

To the human eye, lights often appear white, when in reality they are subtly colored across a wide spectrum: compare the warm, yellow glow of a candle to the cooler blue of a shaded area on a sunny day, for example. These different colors are known as "color temperatures." Our eyes and brain adapt automatically to them, so everything appears "correct" in terms of its color (so a white sheet of paper will appear white under a wide range of lighting situations), but you need to account for them with your camera by adjusting its white balance. If you use the wrong setting then your images may have a definite and unwanted color cast to them.

The white balance settings on most DSLRs include tungsten, fluorescent, daylight, flash, cloudy, and shade. All cameras have an automatic white balance mode as well, where the camera analyzes the scene and selects what it considers to be the most appropriate setting. If there are multiple light sources with different color temperatures, or if you are unsure which white balance is the correct one to use, stick to the automatic setting.

You also need to be aware that colored objects reflect colored light, so photographing someone close to a bright blue wall, for example, will result in a blue color cast on the side of the subject closest to the wall.

THE INTENSITY OF LIGHT

Portrait photographers work with all levels of light, from strong studio flash through to the flickering flame of a single candle. Each light source has a different quality,

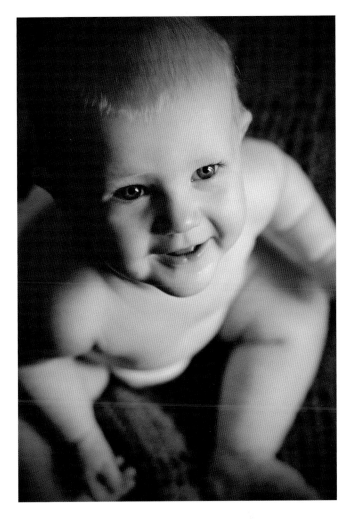

Above: This shot was taken with a large window at the left side of the baby, which has produced shadows on the opposite side of the subject. Shadows can help give a sense of depth to an image, as they show that the subject is three-dimensional.

in terms of its strength and harshness. The broader and closer the source of light is, the softer it becomes, with less intense shadows and reduced contrast. The narrower and more distant it is, the harder the light is. The sun is 93 million miles away from earth, so it produces very harsh light, whereas a large studio light fitted with a diffuser will produce a much softer light.

NATURAL LIGHT

Natural light is freely available and constantly changing. This can make it a challenge, as you will need to adjust your camera settings as it changes, but it also means there are endless variations and opportunities. You'll need less kit than if you were using studio lights, and you will be able to shoot almost anywhere during daylight hours—you only need to be outdoors or near a window. Although you can't control the direction and intensity of the sun in the same way that you can with studio kit, you can use reflectors and diffusers to manipulate the light it produces.

SUNLIGHT

Direct sunlight makes portraiture difficult, as the harsh, directional light makes subjects squint and throws harsh shadows across the contours of a face.

When shooting outdoors on a sunny day, the simple solution is to look for top shade. This can be under a group of trees, shaded ground beneath an overhanging piece of architecture, or just under the cover of a doorframe, for example. Top shade will change the quality of the light, making it more flattering for your subject, and reducing the contrast in the scene. This will make it easier for the camera to capture the full range of light and dark tones.

Alternatively, if there is no top shade around, you can use a diffuser—ask an assistant to hold it in position between the sun and your subject in order to soften and diffuse the light falling onto him or her.

GOLDEN HOUR

Just before the sun rises and sets on a clear day, there is a period of time that photographers refer to as the "golden hour." At this point, the sun is no longer high and strong, but soft and warm in color, and ideal for stunning portraiture. Only at this time of day can you position your subject so the sunlight falls directly onto their face. Alternatively, you can include the sun behind your subject, rim-lighting their hair or producing pleasing flares across your image.

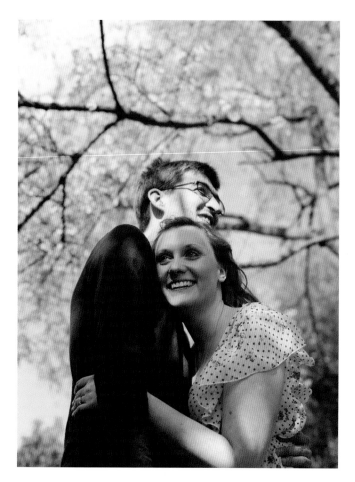

Above: This shot was taken in partial shade, which has resulted in the shadows of the nearby trees appearing as shapes on the subjects' faces. The brightness of the sunlight has also caused heavy shadows in the woman's eye sockets and around her nose.

Once the sun drops out of view (but just before the natural light disappears completely) any outdoor location will be shaded, enabling shots that may not have been possible earlier in the day. If you have a smartphone you can download an app called Magic Hour, which will count down to the hour at sunrise or sunset for your location.

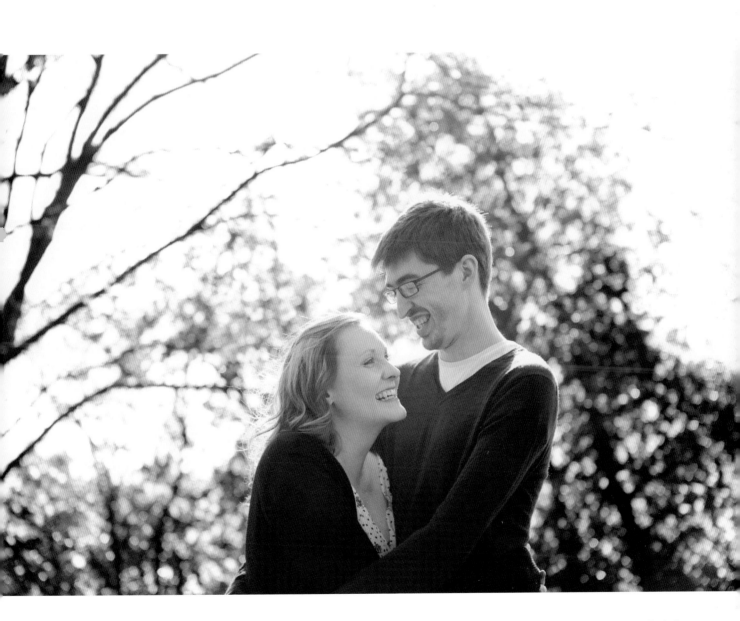

Above: I took this shot in the same location as the image opposite, but the couple was turned slightly. The sunlight hit the back of the man's head, and his body shadowed the woman's face, resulting in more even light across the visible parts of the couple's faces.

CLOUD COVER

Above: On an overcast day, cloud cover acts as a giant diffuser between the earth and the sun, which means the light will be fairly even and ideal for outdoor portraits. As the shadows caused by the diffused light are soft, rather than harsh, no shade was needed for this shot.

WINDOW LIGHT

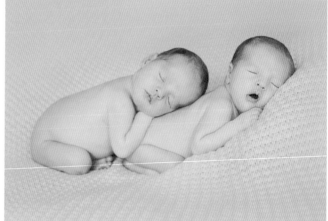

Above: Here, the window was behind the camera, so the light was falling straight onto these newborn twins. The softness of the diffused daylight emphasizes their delicate skin tones.

Although a landscape photographer may be disappointed by cloudy weather, it delights portrait photographers, as the clouds act as a natural diffuser to sunlight. This results in flattering light and greater flexibility, as you won't be restricted to areas of shade when taking photos.

If the cloud cover is very heavy—if you are shooting late in the day or during the winter months, for example—you may need to increase the ISO to compensate for the weaker light levels. You may also want to use a reflector to bounce light back toward your subject. As the light will still be coming from above your subject, positioning a reflector underneath them, angled up toward their face, will help fill any slight shadows.

You don't have to venture far to find great light—large windows and open doors can provide very flattering indoor light for portraiture, especially during the warmer seasons when the sun is stronger. Look for bright rooms with large windows when planning your shoot.

Look out for clutter—one of the challenges of working indoors is that possessions, furniture, and fixings can detract from the subject. Don't be afraid to ask if you can move things about slightly—few homes are designed with photography in mind, and moving a chair closer to a window or clearing the background of toys can make all the difference to the final image.

If your subject is sitting with a large window to one side, the opposite side of their face will be in shadow. A reflector can be used to bounce light into the shadows, helping to make the light more even.

In bright sunshine, consider hanging a thin white sheet in front of the window to soften and diffuse the light, or move your subject slightly further away from the window. The weaker the light, and the further your subject is from the window, the higher the ISO you will need.

Above: This shot was taken indoors, using an overexposed window in the background to mimic the pure white of a studio backdrop. To bounce light back toward the subject, a large reflector was placed between her and the camera, just below the bottom edge of the image frame—you can see its reflection in the subject's eyes.

ARTIFICIAL LIGHT

Using artificial light gives you full control over your lighting, so you won't be at the mercy of the weather or the time of day. You will be able to adjust its direction and intensity, and get a consistency that isn't always achievable outdoors. Artificial lighting can be used as the sole light source, or to supplement natural light.

ON-CAMERA FLASH

Using flash allows you to take photographs in lower light levels without having to resort to increasing the ISO or slowing the shutter speed (which risks degrading image quality or causing camera shake respectively). You can use the light from the camera's flash as the sole light, to supplement ambient lighting when you want to reduce the effects of backlighting (when there is a window behind your subject, for example), or to fill in shadows introduced by the main light source.

However, a camera's built-in flash produces harsh, directional light, which is incredibly unflattering and can produce "red eye." This is when your subject's pupils appear red, due to the light reflecting straight off the retina at the back of the eyes. Ideally, you want to spread and soften the light, rather than flood your subject's face with one narrow beam of light. Some compact cameras allow you to articulate the flash head upward, so you can bounce light off low ceilings or white walls for a more natural effect.

If you have an external flash, you can usually tilt or swivel the flash head so it points toward the ceiling, a white wall at the side of your subject, or even a white wall behind you. Bouncing the light in this way will create a gentler lighting effect, which is much more flattering. You can also buy purpose-built miniature softboxes that fit around the flash, replicating those used in studio photography. For a low-cost version, attach some white fabric over the flash head.

You can use flash as the sole light source or to supplement natural light when shooting outdoors. Again, look for surfaces you can bounce the light off instead of firing straight on, or even aim the flash at a reflector held to one side of your subject.

FLASH MODES

The first flash mode to get to grips with when using a flash is TTL, which stands for "Through The Lens." In this mode, the camera fires the flash once to determine the correct exposure, and then a second time to take the picture. The two flashes occur so quickly that they effectively blend together, making it appear as if the flash only fired once.

However, while TTL flash is effective, if you leave your camera and flash in automatic mode, you won't have any control over the images produced. Instead, experiment with your camera in manual mode: set your camera's ISO to 100 or 200, choose a wide aperture to throw the background out of focus, and adjust the shutter speed to determine how light or dark the background appears. A slower shutter speed will result in a brighter background, while a faster shutter speed will produce a darker background.

Some cameras only enable a maximum shutter speed of 1/200 sec. or 1/250 sec. when using flash. If you set a shutter speed faster than this, the light from the flash will not be recorded evenly across the frame, due to the way the shutter travels across the sensor. However, some camera and flash models offer "high speed sync" flash, which fires the flash continually throughout the exposure, allowing much faster shutter speeds to be used. This is very useful when you are taking shots outdoors on a bright day and you need a fast shutter speed.

As with exposure compensation on a camera, external flashes often have a flash exposure compensation setting that allows you to reduce or increase the power of the flash to get the effect you want. Reducing the flash power is particularly useful when you want to use flash outdoors on a bright day to "fill in" shadows on a person's face, but don't want the flash to be obvious.

Above: On-camera flash is ideal for shots when there is insufficient natural light available. Aiming the flash head toward the ceiling replicates the angle that ambient light usually falls on a subject, while the white, pop-out card on many modern flashes creates catchlights in the subject's eyes.

STUDIO FLASH

One of the benefits of using studio flash (apart from the higher power) is that this type of flash includes a "modeling bulb." This is a low-power continuous light that usually stays on throughout the photoshoot, giving you an idea of how the light will fall on your subject. When you press the shutter-release button, the flash bulbs will fire for a fraction of a second, emitting a much more powerful light to make the exposure.

However, studio flashes don't allow TTL metering, so your camera will not be able to meter the scene accurately. This means you will need to use your camera's Manual exposure mode and a handheld lightmeter to determine the exposure settings for the flash. This typically involves setting the ISO and shutter speed on the lightmeter, then holding it close to the subject's face and firing the flash(es). The lightmeter will calculate the correct aperture to use in order to get an accurate exposure and you can then set the ISO, shutter speed, and aperture settings on the camera. Although this takes a little bit of time, you only need to take one lightmeter reading—unless you change the distance between the subject and the flashes, or alter the flashes' power setting, the exposure will remain the same.

Catchlights are the name for the reflected light that is visible in your subject's eyes as white shapes. Catchlights are a desirable feature, as eyes can appear dull and lifeless without them. Catchlights appear automatically unless the light source is positioned very low, very high, or far away from your subject. When working with studio flash you have more control over where the catchlights appear, as you can use the modeling lights as a guide. As a very rough rule, imagine the surface of the eyes as a clockface, and try to arrange the height and angle of your lights so that catchlights appear at the 10 o'clock and/or 2 o'clock positions. This will give the most flattering effect.

There are two main styles of contemporary studio lighting: high-key and low-key. High-key shots are bright images with few shadows, whereas low-key shots consist mainly of dark tones, with strong, evident shadows. Which style you aim for will depend on the effect you want to achieve, but when photographing young children you will find that high-key lighting has the additional benefit that it doesn't matter too much if the child moves and fidgets. With low-key lighting, you will usually need more precision, as shadows need to be placed carefully. For older subjects, low-key lighting can have a slimming effect on a person and also add atmosphere.

High-key shots are usually taken with white or brightly colored backgrounds. You can buy paper rolls in a range of colors, and these can be held in place by a metal pole supported by two tripods. Ensure the frame is a few feet higher than the subject (so the edges aren't visible in the images), and then simply pull the paper down and out toward the camera, making a smooth curve where the paper meets the floor. Alternatively, a room in a house that has plain white walls and a wooden floor can also be used as a simple, yet effective studio background.

Right: This two-light studio shot uses "high-key" lighting, which means it features predominantly light tones. The main flash is in front of the subject, and 45-degrees to the side, with a second flash aimed at the backdrop to make it appear pure white.

STUDIO SETUPS

ONE-LIGHT STUDIO SETUPS

There are endless ways to position studio lights and pose your subject, but it's a good idea to start with a single light and build from there—here are a few lighting ideas to get you started:

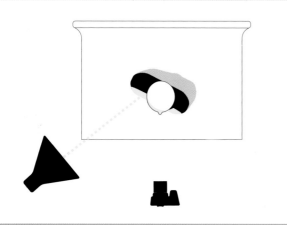

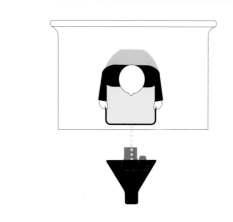

Above: Seat your subject in front of the camera with the light at 45-degrees in front and to one side of them, with their body angled toward it. The light should be above the subject's eye level, angled downward. Ask your subject to turn their face toward the camera—this will result in flattering shadows across the side of the subject's face that is furthest from the light.

Above: Position the light directly in front of your subject, raised 45-degrees above his or her eye level and angled toward them. With your subject facing straight on to the camera, ask them to hold a reflector below their chin, angled up toward their face. This will create flattering light with gentle shadows on the cheeks.

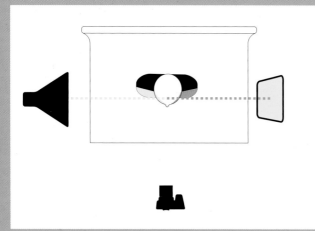

Left: Place the light directly to one side of your subject, level to their head height, and facing toward them. This will result in one side of their face being hidden in shadow when your subject is straight on to the camera. Try using a reflector on the side opposite the light to subtly lift the shadows.

TWO-LIGHT STUDIO SETUPS

Although it's possible to take great portraits with just one light and a reflector, most portrait photographers will use two (or more) studio lights for greater versatility and control. Here are a few simple two-light setups:

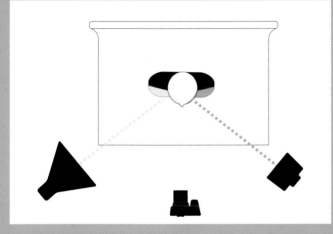

Above: Position the lights 45-degrees in front of, and slightly to each side of, your subject. Set one light at a high power setting (this will be the "main" light) and the other at a lower power setting (a "fill" light) to lift the shadows. The lights should be high enough to make catchlights appear in your subject's eyes at the 10 o'clock and 2 o'clock positions.

Above: Place the main light 45-degrees in front, to one side, and slightly above your subject's head height. Position the fill light behind your subject, aimed toward the background. This will provide some visual separation between your subject and the background. It will also ensure a white background looks bright (instead of a dull gray color), and will stop a subject's dark hair merging with the dark tones of a black background.

Left: Position the main light 45-degrees in front, to one side, and slightly above your subject's head height. Position the fill light behind your subject, aimed toward your subject's hair. This will produce a halo of light that lifts his or her hair from a darker background, or rim lighting that adds shine to hair on a lighter background. To avoid lens flare, make sure the fill light isn't shining directly into the camera.

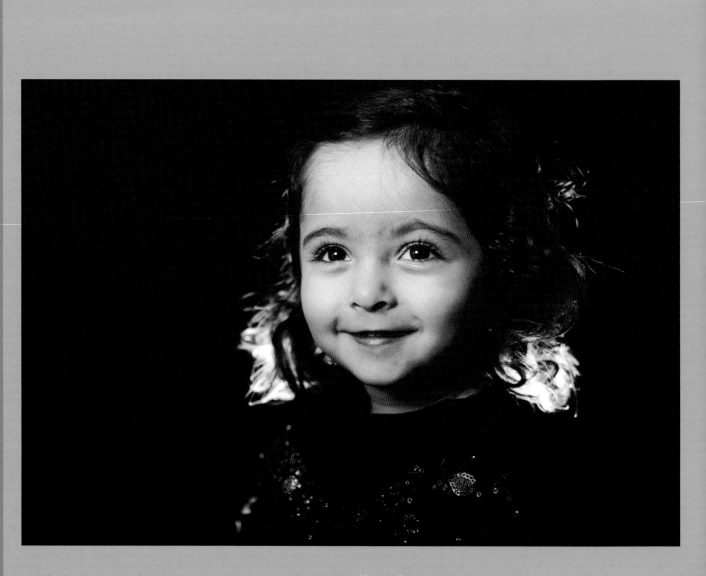

Above: This is a "low-key" image, as it features predominantly dark tones. The main light is in the same position as the high-key shot on page 49 (in front and at 45-degrees to one side of the subject), but the second light is pointing toward the subject's hair, rather than at the background. This provides separation between the subject's hair and the black background.

REVISION

- The direction of the light affects the position of any shadows on your subject. Some shadows are flattering (when they slim the face, for example), while others are considered unsightly (such as dark shadows in eye sockets and under the subject's nose).

- Light isn't "white"—there are various tints that can add an unwanted color cast to your images. The camera's automatic white balance function will analyze a scene and suggest the most appropriate setting, or you can manually select the correct setting for the light source you are using.

- Broad, close light sources (such as studio softboxes) are softer and more flattering than narrow, distant light sources (such as the sun).

- Sunlight is harsh and makes subjects squint. Head for shaded areas where the light is more flattering, or use a diffuser to shield your subject from the sun's glare.

- At sunrise and sunset there is a period called the "golden hour," when the sun produces a soft, warm light. You can position your subject so the light falls on their face or behind them, rim lighting their hair and producing a pleasant lens flare.

- Cloud cover is nature's own diffuser for sunlight, producing the ideal conditions for portraiture. If necessary, raise the ISO and use a reflector to lift shadows and boost the amount of ambient light falling on your subject.

- Use bright rooms with large windows when shooting indoors. Make sure the background is free of clutter and hang thin, white fabric in front of a window if the sun is shining directly through. Again, use a reflector to lift shadows and boost light levels.

- On-camera flash is best used when it is bounced off a wall or ceiling, rather than fired directly toward a subject. Use flash compensation to change the power of the light.

- High-key studio lighting features bright tones and few shadows, while low-key lighting is darker with more shadows. Position your lights so that catchlights appear in your subject's eyes at the 10 o'clock and 2 o'clock positions.

SOURCES OF LIGHT

Aim: To shoot a series of portraits using a variety of natural and artificial light sources.

Learning objective: To understand the effect that lighting has on creating an exposure and flattering a subject.

Brief: It's time to get started! For this project only, set your camera to its Program (P) or Automatic mode. Then, ask a friend to model for you and take ten completely different shots of him or her in a variety of natural and artificial lighting conditions. In each situation make a few notes about the quality of the light.

How intense is the light? Remember that the closer and more diffused the light source, the softer and more flattering the resultant light will be. Seating your subject very close to a large window will produce a softer light than a small window far away from the subject. The sun is a harsh, distant light source, while cloud cover acts as a natural diffuser.

Has the light got a color tint to it? Use the white balance settings on your camera to correct for the different types of light you encounter.

What direction is the light coming from? Notice how the light is falling on your friend's face and ask them to gradually change their angle so you can judge the most flattering result. Some shadows are unflattering, others can be flattering.

You may want to try modifying the light, by using a reflector to bounce it or a diffuser to soften it. You can buy these items, or improvise—a sheet of white card and aluminum foil can be used as white and silver reflectors, for example, while a thin, white bedsheet will make a great diffuser.

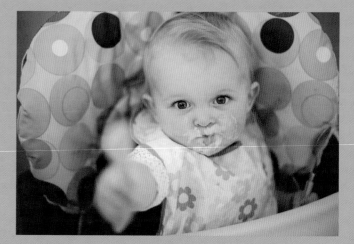

Above: This girl's highchair wasn't very close to any windows, so for this shot I aimed my on-camera flash at the wall behind us, creating a more natural effect than having the flash facing directly toward the subject.

You could start with a shot in a shaded area and then head to an area in direct sunlight. Experiment with using the on-camera flash to fill in the shadows while the sun is behind your friend, then change position and try the same thing with the sun falling onto your friend's face. Take another shot while the sun is behind the clouds and one during the golden hour.

Then head indoors and take some shots close to a window. Ask your model to step further away from the window and use flash to supplement the light levels. Close the curtains or wait until dark and try using the light from a household bulb as your light source. Finally, you could try taking a shot using an alternative light source such as a candle or a flashlight, for example.

Above: Studio lights provide the same, consistent light output for each shot. Unless you change the power of the lights, or move the lights closer or farther away from the subject, there is no need to adjust your camera settings after you take your initial exposure reading.

Above: The light is soft and even under top shade, so there are no harsh shadows across the faces of my subjects in this shot. I have exposed the image to ensure the skin tones are recorded accurately, which has resulted in the bright background becoming overexposed. You will often need to make compromises like this when there is a wide range of tones in a scene.

TIPS

- Increase the camera's ISO setting to make the sensor more sensitive to light in order to create a brighter exposure. Reduce the ISO for less sensitivity and a darker exposure.

- Use a reflector to bounce light back onto your subject's face when you want to reduce shadows.

- Use a diffuser to soften direct sunlight by placing it between your subject and the light.

- When using flash, aim it toward the ceiling or a white wall, rather than straight at your subject.

ANALYSIS

When you have taken a selection of images, download them to your computer and pick the ten that you feel best demonstrate an effective use of lighting. Some may be obviously better than others, but it may help you to narrow down your selection if you ask yourself questions about your photographs:

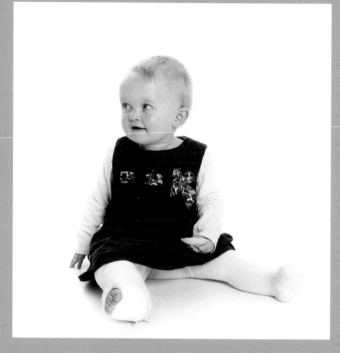

Above: The pale tones of this girl's top and tights blend in to the pure white of the studio background. Encourage subjects to wear bold colors when using light-colored backgrounds or invest in some dark or colored paper rolls to use as a background instead.

1 Which scenes did your camera struggle most with? Images taken in lower light levels are more likely to be blurred by camera shake, while some camera models won't allow you to take the shot if they consider the scene too dark. Taking the camera off automatic mode ensures you have more control and enables you to change the settings to cope with different lighting conditions.

2 If your camera has the ability to, display the histograms next to or over each image you've taken. Which images have lost detail at the dark or bright ends of the spectrum? How does the shape of the histogram change in relation to the different scenes? While there is no right or wrong shape for the histogram, practice will quickly help you determine whether it looks right for the particular scene you are shooting, and the number of light and dark tones in the image.

3 Look at the settings chosen by the camera for each shot—which combinations of shutter speed and aperture were used? How did these vary among the different lighting conditions?

4 Which lighting conditions are the most flattering? Which are the most atmospheric? How do the shots taken with artificial lighting compare to those taken using ambient light?

5 Is your subject squinting his or her eyes? If the light is too strong, they will struggle to keep their eyes fully open. Find top shade, use a diffuser and/or change the position of the subject so that the light is to the side or behind them.

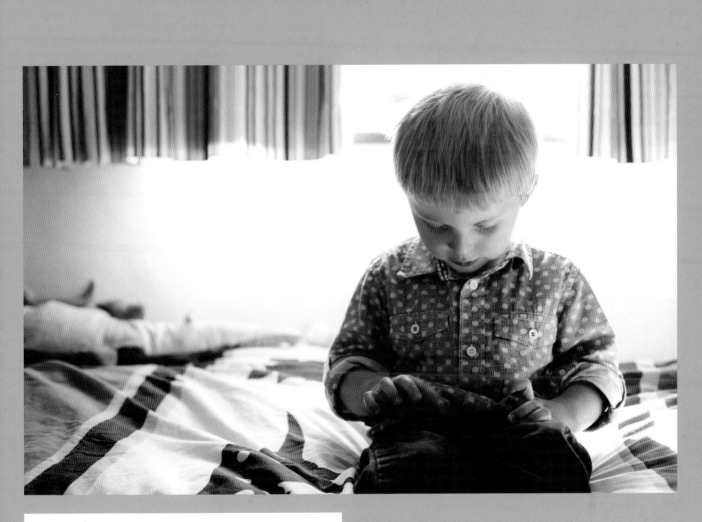

6 When using them, check that the edges of your reflector aren't visible in your final shots and that the outline of your diffuser isn't evident by the shadows on your subject.

Above: The subject's rim-lit hair has merged into the bright background in this shot, making its shape unclear and losing a lot of detail; positioning the boy away from the gap in the curtains would have helped with this. A white wall to the left of the child is acting as a reflector, bouncing light back onto his face, but his right side is in darkness—an artificial reflector would have evened out the shadows on that side of the photograph.

REFINE YOUR TECHNIQUE

If you want to take your lighting experiments to the next level, consider undertaking the previous project again, this time incorporating some of the following techniques:

• Experiment with including flare in your image. Shoot in the hour before sunset when the sun is low in the sky, and focus on exposing your subjects correctly. As the light source is included in the shot, there will be such a wide dynamic range that the camera will struggle to capture all of the tones. Use editing software to help bring back the depth of tone to these areas.

• Invest in a radio or infrared transmitter so that you can use your external flash unit away from the camera. This gives you the option to position the flash anywhere in the scene, or combine multiple flash units for creative effect. Some camera and flash combinations will allow you to use TTL metering to ensure the light emitted combines with the ambient light to create a balanced exposure.

• If you have studio lighting, experiment with the position, strength, and direction of the lights. For example, you could keep one half of the subject's face in complete darkness for a moodier shot, or use a third light on a white background for a very high-key shot. You could also try using different attachments, such as a brolly or softbox, to change the quality and softness of the light.

• Use some less common light sources, such as candles, spot lighting, tungsten bulbs, flashlights, and mood/party lighting. These are ideal for use with older subjects who are likely to be more patient than young children and can sit still for longer! Many indoor light sources emit a weak light, so you will need a tripod and a slow shutter speed to get the correct exposure.

Above: Artificial lighting isn't limited to on-camera flash or studio lighting—practically any light source can be used for portraiture. Here, fairy lights have been used, but as they are very weak, a wide aperture (f/1.8) and a slow shutter speed (1/10 sec.) were needed to allow as much light as possible to reach the camera's sensor.

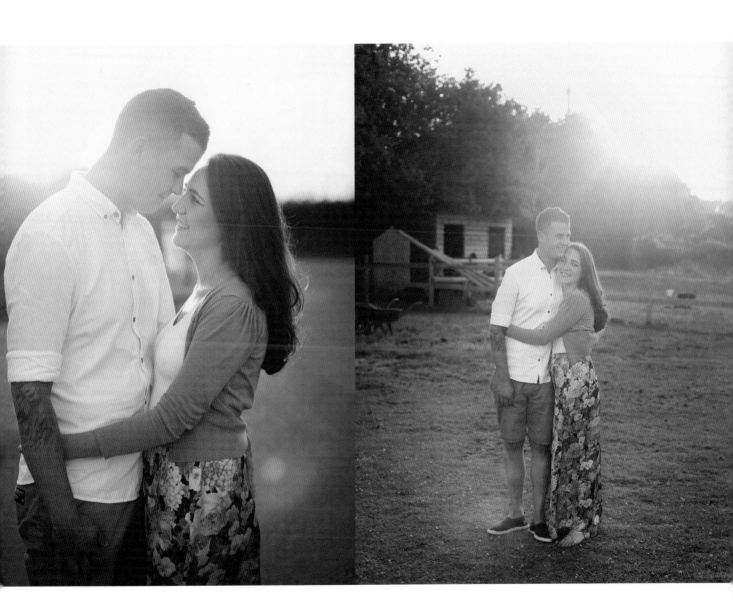

Above: Lens flare can add warmth and atmosphere to your portraits, but it's tricky to capture correctly. The sky will probably be overexposed, so the priority is to make sure your subjects are recorded correctly.

PLANNING A SHOOT

Locations provide a backdrop to your portrait and set the mood of the shot. As you learn what kinds of backgrounds create different effects you will become better at spotting them—often a great background is one that most people would walk straight past. Combine your new awareness of potential locations with lighting know-how and you will be able to create stunning portraits almost anywhere!

Whether you want to shoot indoors or outdoors, potential locations are not at all hard to find. As long as you have light and room to move around in, there is usually a way to make it work. For example, you might think that shooting in a derelict street would be awful, but with clever crops and angles, no-one would guess where the shot was taken. You might see a door with peeling paint as an ugly backdrop, but adjusting your aperture so it's blurred could transform it into a welcome splash of background color and texture that lifts your portrait. The key is to train your eye to start assessing your surroundings for opportunities.

Before planning a portrait shoot, discuss potential locations with your subject (or their parents if you're photographing a child). Your images will have much more significance if they are taken somewhere that holds particular meaning to your subject. For a family this could be a favorite local park, while for a couple it might be where they first met or became engaged.

If the images you are creating will be put on the wall, find out what room they will be displayed in. Taking the photos in the same room means the final prints will match the decor. Alternatively, use locations, props, or clothes that contain colors that complement those in the room the photo will be hung in.

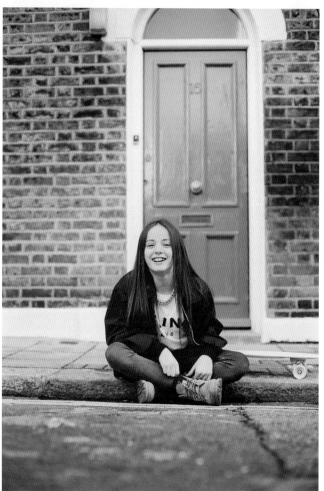

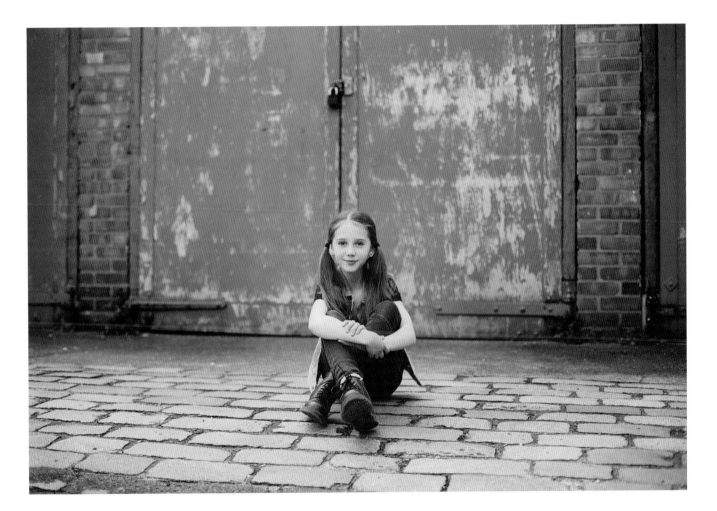

Left Top, Left Bottom & Above: This street corner (left top) didn't look promising at first, but it actually provided some great backgrounds. The faded green paint of the garage door at the left of the shot created a great out-of-focus textured background (above), while the blue door at the right added a welcome pop of color behind the subject (left bottom).

Above: Taking this shot in the young girl's bedroom means it will have more resonance in future years: not only is it a nice portrait of her, but it also serves as a reminder of the room she spent many years growing up in as a child.

You will also need to consider the atmosphere your location will convey. What emotion do you want the shots to conjure up? If you're photographing a fashion-conscious teenager, you may find an urban background gives your images an edgier feel, while a meadow full of flowers will set a more romantic scene for a newly-wed couple.

The best backdrops provide color, texture, and background interest to your portrait. To ensure your subject's face takes center stage, use a wide aperture and increase the distance between your subject and the background to make it as defocused as possible.

When there are patterns or perspective lines in your location, use them to enhance the composition—diagonal lines can add energy and make a shot more dynamic, whereas perspective lines (such as a row of trees or a path) can draw your eye into the image.

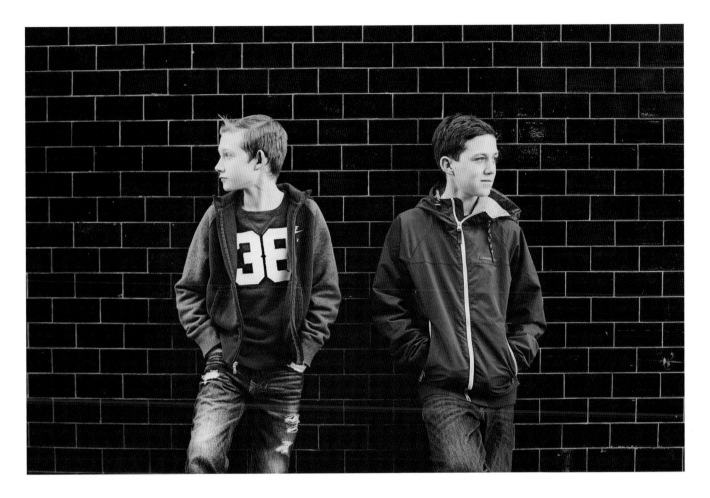

Simply changing your angle can help you get the most from each location. Taking a photo while lying on your stomach will change which part of the background is visible compared to a shot taken from your eye level. Keep experimenting and moving, and you will instinctively start to recognize the best angles.

Finally, you may want to combine two or more locations to ensure a varied set of images, perhaps starting off at home, then wandering down to a nearby park for a completely different look and feel. You could ask your subjects to change their clothes during the transition too, so the photos will look very different in the two locations.

Above: Use the background to add interest to the shot in line with the style you are aiming for. This blue-tiled wall echoes the colors of the boys' clothing, but more importantly it suited their urban-cool expression and pose.

LIGHT & LOCATION

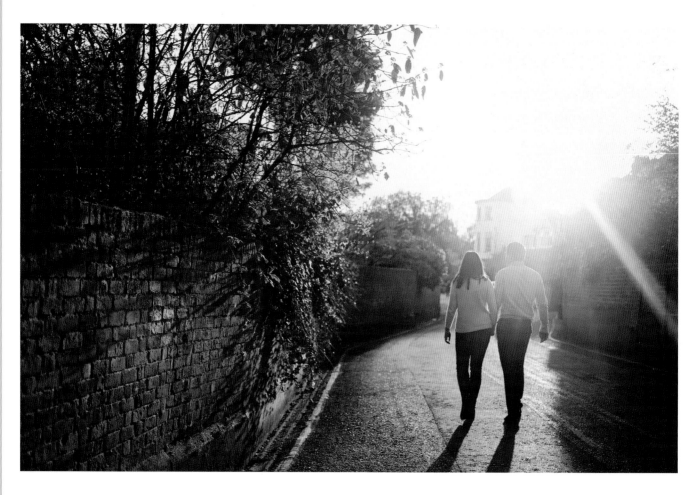

Different locations bring different lighting challenges. When shooting indoors, you will be restricted to the brightest rooms with the largest windows unless you are using flash or some other type of artificial lighting. Outdoors, you will need to contend with the weather conditions and direct sunlight. This can often be too harsh for portraiture, except during the early morning or late afternoon.

People tend to say there's nowhere suitable to take good photos in their own homes. They think that their rooms aren't good enough because they haven't been dressed by a professional interior designer, or there's no suitable space

Above: Light and location are inextricably linked: this country road looks quite unimpressive when seen on a rainy day! Notice how the jagged curve of the wall and the road keep drawing your eye back to the couple. Place your subjects carefully in a location like this so that the lines of the background lead toward them.

because they have too much clutter. Actually, all you need is some natural light and a blank wall to get started.

People tend to feel more comfortable in familiar surroundings, so if you're shooting nervous subjects, starting off in their house will help them feel more relaxed. One caveat is that there isn't enough shade in most gardens, and often there's limited space: if the sun is

strong and you are photographing energetic kids, you may be better off in a local park. Choose one where there are plenty of trees for shade and enough space to explore that you don't have to stay in one place for long.

AT HOME

For babies and toddlers, some of the most meaningful photographs can be taken in a child's bedroom, where they are fully relaxed and surrounded by their favorite toys. The parents have often spent a lot of time picking out the decor and there is an opportunity to capture details from the room that the family will remember fondly in years to come.

Above: People tend to focus on the chaos in their house and the things they would like to change about it, rather than the parts that lend themselves well to portraits. The master bedroom often has large windows and—combined with white bed sheets—can make a great location, especially for baby portraits like this one.

For sleepy newborns, you will be restricted to shooting indoors so you can maintain the consistent warmth required to keep them comfortable. Even for teenagers and adults, you may want lifestyle shots that show the subject in their day-to-day environment.

Time your shoot for when the house gets the most natural light—often the best time is in the mornings.

Above: The simple colors and natural light streaming onto this staircase made it an ideal location for some unique portraits. The stairs and handrails add understated background detail that gives the image a sense of place.

Use rooms with large windows that allow plenty of natural light in. Houses with skylights or windows on two sides of a room can provide especially good lighting. If the sun is shining directly into the room, diffuse it by hanging a thin white sheet across the window.

Look for backgrounds that aren't too cluttered—a plain, light-colored wall is all you need to get started. Most people are happy for you to move furniture around to get the best light and background, so just ask. Hide away any smaller objects you don't want to include—a few seconds spent picking them up before you begin will save you having to edit them out in postproduction.

Even if the windows are all small and the house is quite dark, there is at least one place that always has more light—just inside the front and rear doors. Prop open the door and stand outside the house to take the photos, with your subject positioned just within the shade of the interior. Be aware that during the winter months it may be too dark indoors to get sufficient natural light for good shots.

THE GREAT OUTDOORS

Natural environments offer limitless opportunities, and can offer appealing backgrounds for relaxed and informal portraits. Although less private than indoor locations, natural environments tend to be a lot less busy than urban spaces, making them better for subjects who prefer not to have an audience while being photographed. They allow more space than indoors, which is great for action-driven shoots

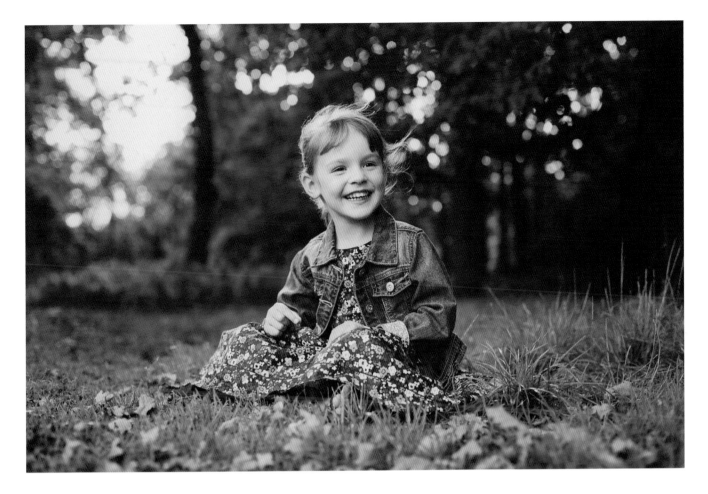

involving children. They also enable you to be spontaneous as you explore—you may come across a pile of logs or a path lined with wildflowers that you couldn't have planned for. They also have fewer hazards (such as road traffic), which means children are safer and parents less tense.

Possible locations include beaches, fields, meadows, woods, forests, and parkland. The key to making any of these work as a great background is getting the lighting right. A beach, field, or meadow would be best on an overcast day, as they don't tend to have a lot of shade, while woods, forests, and parkland offer lots of top shade and therefore work well even on very bright days.

URBAN BACKDROPS

Urban locations give an edgier, more contemporary feel to portraits and are ideal for extroverted subjects who don't

Above: Shots taken in favorite locations will evoke all the memories of the fun times had there. As well as offering a variety of backgrounds, this local park also provided sufficient space for moving, running, and interacting with the children in order to get genuine expressions, such as this one.

mind the attention of curious members of the public. Again, lighting is key. On a bright, sunny day you will need to find top shade until the sun is weaker in the sky. During the golden hour you will find that lens flare, the soft glow of the light on your subject, and using the light as a rim light can completely transform the atmosphere of your photos. Buildings start to block the sun as it sinks in the sky, so find roads facing the right direction to catch the last of the light.

City centers offer myriad background options. Look for brightly colored doors, walls, and any other surfaces that will look great blurred out in the background. Use the lines

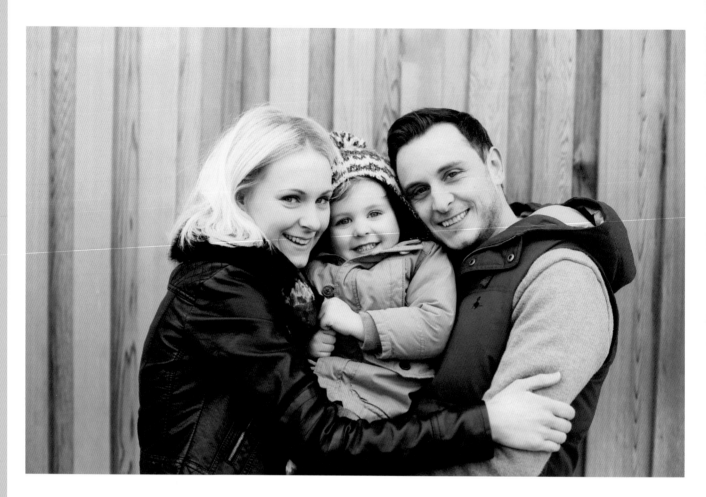

Above: You don't need to go far—potential locations are everywhere. Start imagining how different surfaces will look as out-of-focus backgrounds—sometimes the color will be amazing, sometimes the texture. A wooden wall may not seem a likely candidate for a family portrait background, but it works well here.

created by the sidewalk, buildings, and even rows of cars to produce powerful compositions.

Sometimes you will be more limited in terms of where you can photograph from—if there are parked cars in the way, for example—but use your creativity to get around them. Could you shoot from the other side of the car and zoom in, or include the car in the shot somehow? There are also more background distractions to watch out for, such as signposts that appear to be coming out of your subject's head in the photo. Change your angle or crop them out. Also remember to look out for stray litter and move it aside before taking your shot, to save yourself editing it out later.

When photographing children, remember that you're also a role model—make sure you always cross roads properly and stay off private property if you don't have permission to be there. Safety comes first, so if you're taking a shot

that requires the subject to stand or walk in the middle of the road, choose a quiet side street and ask an assistant to watch out for traffic.

Other people are likely to be interested in what you're doing; stay friendly and polite. Be ready to get out of the way if you are blocking access and be patient when waiting for people to move out of the frame.

REVISION

Left: A good location will complement your subject and add background detail. Here, the black railings frame the sides of the image, while the lowest step borders the bottom. The brightly painted door offers a splash of color that matches the shades worn by the subject.

- Change how you view your surroundings: start looking for suitable locations by seeking out opportunities, rather than focusing on problems.

- If possible, make the final images more meaningful by shooting in a location that is an important part of your subject's life story, whether they love playing there, met their partner there, or just go there at every opportunity.

- Consider the message you want your image to convey, whether that's romanticism, urban-cool, fun and funky, green and earthy, or something else. Choose your locations accordingly.

- Experiment with your angle and subject placement to make the most of the location, positioning any key elements of the location—such as a wall, path, or line—so they add impact to the final composition.

- When taking photographs indoors, choose the brightest rooms and the brightest times of day to ensure sufficient natural light. Move furniture around and clear away mess if it allows you to get things how you want them.

- Natural environments can make spectacular backdrops that are especially well suited to families and children, as there is space for everyone to move around safely and interact. When the sun is out, choose areas with top shade to avoid harsh shadows falling on your subjects' faces.

- Urban locations bring a lot of challenges, but also force you to be creative: look for colors or textures that will enhance your subject, using areas with top shade if it is especially sunny.

UNDERSTANDING APERTURE

Aim: Take photographs in ten completely different locations, at least half of which are unusual places.

Learning objective: Understand how the aperture setting affects the background.

Brief: Ask a friend to model for you and put your camera in Aperture Priority mode. For this project you will need to change your aperture from the lowest to the highest setting in each location.

The wider the aperture, the less depth of field—this is the amount of the image that is in focus in front or behind the sharpest part of the shot. This technique is commonly used in portrait photography to achieve an aesthetically pleasing blurred-out background. Remember that a wide aperture is expressed in a low "f" number, such as f/2.8 or f/5.6, for example. A small aperture is represented by a high "f" number, such as f/18 or f/22. Enthusiast-level lenses don't offer as wide an aperture as professional lenses, so depending on your kit the lowest aperture you can set may be f/5.6. Moving your subject further away from the background will help to ensure the latter is more out of focus, even if you are unable to access the widest aperture settings.

Starting indoors, look at each room and assess its potential as a portrait background. Position your friend in one of the rooms, set the smallest aperture available to you, and take the shot. Change to the widest aperture setting and take another shot.

Next, head outdoors and look at everything around you as a potential background opportunity. Each time you take a shot, vary the aperture setting.

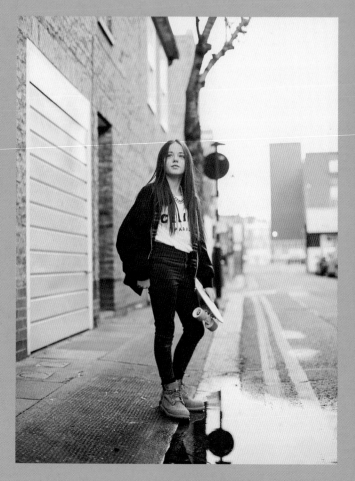

Above: This garage door is the exact shade of blue as my subject's eyes. I took a bust shot with the door blurred out, followed by this full-length shot, using the reflection in a puddle. The yellow lines, curb, and pavement all help to draw your eye into the image.

You might come across a rickety door or a shop window with an unusual display. Position your subject in front of each background and shoot a series of images using a variety of aperture settings. Even an interesting sidewalk, such as cobblestones or wooden decking can work—ask your friend to sit down and take the shot from a standing position so the background is filled by the textured floor.

Above: For this shot, my model perched on the edge of a standard sidewalk curb and I cropped in close. The background gives an urban feel to the shot, but it's simple enough that the focus of the shot remains on the subject's stunning blue eyes.

Above: The master bedroom in this house had afternoon sun streaming through the large windows. I asked the girl to lean against the ledge of the window frame with her back to the sun so her face was in shade. The lens flare gives the shot warmth and atmosphere.

TIPS

- Increase the camera's ISO setting to make the sensor more sensitive to light in order to create a brighter exposure. Reduce the ISO for less sensitivity and a darker exposure.

- Experiment with the distance between your subject and the background, and adjust the aperture to see what effect that has as well.

- Try to include some natural backgrounds (trees, meadows, and so on), as well as manmade ones.

- When including backgrounds that contain patterns or lines, try tilting your camera so the lines run diagonally across the frame behind your subject— this can add energy to the composition.

ANALYSIS

As with the previous project, once you've taken your shots, open them on your computer to choose your "top ten." Look at the elements that work (and those that don't), paying particular attention to the backgrounds in your images.

1 How does the aperture setting affect the sharpness of the background? How does the distance between the subject and background increase or decrease the sharpness of the background in your pictures?

2 Look at the settings the camera chose for the shutter speed of each shot. How did changing the aperture setting affect the shutter speed?

3 Do the subject's clothing and location suit the style of image you are aiming for? Floaty summer dresses may suit a romantic photoshoot, but ripped jeans may work best for an urban teen shoot.

4 Check for unintentional distractions, such as litter in the background, or a tree or signpost that appears to be growing out of your subject's head.

Above: Check for litter in your shot, particularly when working in urban locations. Removing the bottle behind my subject before taking this shot would have been much quicker than editing it out in postproduction.

Above: A slight change of angle would have changed this shot from "tree growing out of the subject's head" to "tree in the background" (see page 70). Check the placement of any objects behind your subject so they don't appear to be connected to your subject in an unintentional way.

Left: You will need to be patient when working in busy locations. Time your shot when there are no unwanted distractions, such as the pedestrians just behind the subject in this photo.

REFINE YOUR TECHNIQUE

You can take your use of locations to the next level by employing one or more of the following techniques:

- When you come across a potential location, revisit it at different times of day to experiment with varying lighting conditions. Explore how the atmosphere of the location changes during golden hour, under cloud cover, or when using a flash, for example.

- Use what's available in your location to strengthen the image's composition. A gap in the branches of a tree

Above: Use your location to add strong compositional elements. In this shot, the bench leads the viewer's eye to the young boy sat upon it. Often this comes down to experimenting with your angle: get down low or up high—you are missing out if you always shoot from your own eye level.

could frame your subject, or a path could lead your eye into the image, for example.

- Have you found an appealing location, but it's a little dark? Try using a flash to boost the light levels. Bounce the light off a reflector for a more natural lighting effect.

Left: Combine your location with appropriate lighting to create an atmospheric shot. The soft golden hour light magnifies the natural beauty of the field in this shot to create a stunning portrait.

Left: Find elements in your location that can form a unique frame for your subject. In this shot, the handrails of this staircase create a frame around the couple's faces. This viewpoint gives the impression of a private moment captured without the couple knowing.

PART THREE
PEOPLE & POSING

Photographs prompt memories. When someone looks back at a portrait you've taken, you hope that they will think about how much fun they had at the time, rather than remember how uncomfortable they felt, or how badly behaved the kids were that day. In addition, it's easy for other people to look at the shot and notice if the subject looks awkward or has a fake smile.

That's why portrait photographers have a tough job. Not only do they need to be confident with their camera settings, but they also need to have the ability to make their subjects relax and generate a rapport that results in the desired expressions. People skills are just as important—if not more so—than technical competence.

Forward planning will help you get the best results from each shoot. What kind of images do you and your subject (or their parents) hope to get? Which colors will complement the background and/or each other's outfits?

Think about your timing too: you can take photographs of older subjects during the golden hour, but you may find younger children are more amenable during the morning.

Have a plan so that you can confidently guide and direct your subjects through the shoot, but be open to creativity and spontaneous opportunities too.

Finally, when you're concentrating on building a rapport and making your subjects laugh, it's easy to get carried away enjoying the moment—don't forget you are there to take photos! Learn to anticipate when your interactions will make a subject react so that you can get the camera in position and have your finger ready to press the shutter-release button and capture those smiles.

SAFEGUARDS

With the current awareness and fear of inappropriate and/or illegal behavior when taking photographs of children, mom and dad should remain in the room at all times, especially if you are photographing children outside of your family and immediate circle of friends. It goes without saying that you should never take photographs of any child without the parents' explicit permission.

Left: For this shot, I asked the twins' mom to pretend to be a monster, then told the boys to squeeze each other to keep safe and shout if the monster was going to get me. I kept asking, "Is she there? Is she going to get me? I'm scared!" and the boys were laughing and screaming. Once I had the camera settings right, I could snap away, focusing on getting genuine reactions like these.

BABIES (0–12 MONTHS)

There are few things that compare to being asked to photograph a proud parent's new arrival. Babies change and develop so quickly that the photos you take today will soon be the only record of how they looked at that time. However, you will need to consider the baby's abilities and milestones at each age when planning a shoot. Patience and confidence are crucial: you will need to work around the baby's feeds and moods, while also exuding calm so that both the baby and his or her parents will relax while you work.

Above: Full-length shots of newborn babies are perfectly complemented by close-ups of their tiny features, which wil change rapidly over the first few weeks.

NEWBORNS

The best time to get a shot of a sleepy, curled-up newborn is when the baby is between one and two weeks old. In most cases, the baby will be settled and feeding properly, but will allow you to adjust their pose while they're asleep.

Excited new parents often want to capture their son or daughter just as nature created them—naked. In order to ensure the baby is comfortable you need to warm the room to about 86°F (30°C).

Think about when and where to have your shoot. The most successful time tends to be in the morning, immediately after they've been fed. Shoot indoors so you can control the ambient temperature, and choose a bright room with plenty of natural light—flash will kill the atmosphere and possibly wake the baby. Bear in mind that newborn shoots can take between four and six hours, so if you start the shoot too late in the day (particularly during the winter months), you can quickly run out of natural light.

Beanbags, beds, and large sofa cushions placed on the floor can all work as places to lay the baby. Cover whatever soft surface you choose to use with a large, clean blanket. Blankets enable you to have a variety of colors in the final set of shots and also create a seamless studio-style background. Remember that the baby won't be wearing a nappy, so anything you use may get dirty.

Use a hot water bottle filled with warm (not boiling) water to heat the blankets slightly so the chill of the fabric on initial contact doesn't wake the baby. For shots from above, create a hollow in the blankets to cradle the baby; for shots from the sides, a firmer, flatter surface normally works best.

Start by laying the baby on their back and then slowly and gently tidy up the pose so that the hands and feet are where you need them to be. For nude shots, bend the knees and cross the legs to hide the baby's private parts. Each time you press a limb into place, hold it there for a few seconds until you feel the baby relax into the pose.

Afterward, gently move the baby onto his or her side, changing the blanket at the same time for maximum variety. Change your angle and experiment with the distance and direction of the light falling on to the baby—having the baby parallel to a window will mean the light is flatter, with fewer shadows, which works for some shots but not others.

Getting newborn shots perfect takes lots of time and patience. If the baby wakes, take photos of details in the room or focus your attention on any siblings while the baby is settled again.

Above: There's been nine months of nervous excitement and preparation leading up to the new arrival. While the baby is feeding, use the time to capture details around the house that tell the story of the love and anticipation that has led to this moment.

Above: For many moms, one of the most precious memories of parenthood is the time spent cuddling up to their new son or daughter, inhaling the scent of their skin and falling in love with them. Lifestyle shots like this capture those moments perfectly.

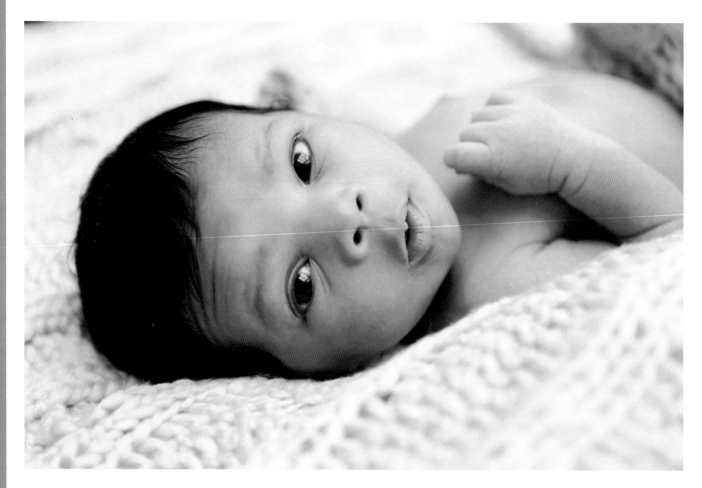

ONE TO SIX MONTHS

Babies quickly start to interact with their environment, and after a month or two you will be able to start capturing their eye contact, reactions, and smiles.

However, babies are building up their neck muscles over the first six months to become strong enough to support their own head, so you will be fairly limited in how you can pose them before the half-year milestone. They will need to be lying down, either on their back, side or—for short periods of time only—their tummy.

As with newborn babies, it's up to you to create variety by regularly changing the background, shooting angle, and lighting. Textured blankets in a range of colors are again ideal, but also use what is available to you in the baby's house. The parents' bed could make a good location, for example, or even the baby's changing mat, depending

Above: As babies are not able to support the weight of their heads until about six months, you are limited to posing them on their back, side, and front (for a short time). Use blankets with appealing colors and tactile textures to add variety and interest to your shots.

on its pattern. If the baby will be naked, ensure the room is comfortably warm (for them, not you) and cover their private parts with their legs, blankets, or by changing the camera angle.

Find out where the parents intend to display the images and try to use a suitable color palette in the photos: if they are going to be put up on the wall in a room that's painted cornflower blue, for example, try to incorporate the same color in your photographs. To do this, you could use a blanket, props, or clothes of the same color, or simply shoot in the same room that the photographs will be displayed in, with the cornflower blue walls in the background.

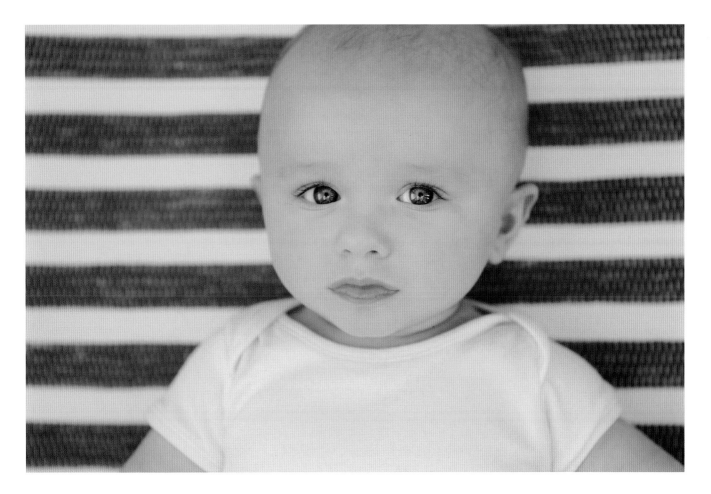

Time the photo session around the baby's routine. There is usually a time of day when the baby is most calm and happy, so make your job easier by arranging the shoot then. Take regular breaks and allow sufficient time so that the shoot doesn't become pressured.

While the baby is awake, talk, sing, and interact with him or her to see if you can prompt a smile, but also be ready to capture other expressions, too. The baby's vision will still be developing, so move in closer to their face until they respond to you. While they are sleeping, capture close ups of their hands, feet, eyelashes, and thumb sucking.

As with all ages, the baby's safety comes first, not the photographs: parents need to stay close by and are responsible for their baby at all times.

Above: Babies have an enormous repertoire of expressions, from the gummy smile right through to the serious frown. Capture every one you can, but also get neutral expressions such as this one, where the baby's eyes are at their biggest.

SIX TO EIGHT MONTHS

At this age, most babies can confidently sit unsupported, but not yet crawl. This is a great time for portraits, as your subject will stay wherever you put them! This gives you time to experiment with your camera settings and viewpoint, safe in the knowledge that your subject won't crawl off.

The baby's vision will also be much better developed, so they will be able to interact and respond to you much more than at an earlier age. Seek to capture the baby's giggles and their rolls of baby fat. Use poses that show that the baby is now holding his or her head up by themselves—such as by laying them on their tummies. As with younger ages, find out what the parents want to do with the final images and keep that in mind by including colors that will complement those in the room the photographs will be displayed in.

You may want to put the baby in a favorite outfit or something they have recently been bought, or you could include a family heirloom in the shot or the soft toy that the baby sleeps with each night. Including elements such as these will help to make the photographs more personal and unique—just make sure the baby is still the star of the shot!

Time your shoot for when the baby is usually at their happiest, which is often first thing in the morning. If the baby has started teething, try and change your angle so you capture their baby teeth when they grin, usually by shooting from above the baby's eye level.

Regarding locations, start with the brightest rooms in the house and those that have the simplest backgrounds. Then, add variety by changing the baby's clothes, using textured blankets and out-of-focus details in the background, and by capturing "real-life" moments, such as the baby eating a messy meal in their high chair.

By now, babies can usually roll themselves, so shoot at floor level or position a parent next to the baby, just out of the shot (making sure their body doesn't block the light and cast a shadow across the baby). Sing, make unusual noises, and tickle the baby to make them look up and/or smile. Ask whoever is helping you to move back next to the lens when you get the expression you want, so that the baby appears to be looking straight at the camera. You could also use a bubble gun to get their attention—at this age bubbles will entrance the baby.

You may also choose to include the parents by getting mom and dad lying on their stomachs with the baby on his or her tummy between them. Parents often put their heads further back than the baby's, so ask them to imagine there's a pane of glass in front of everyone and you need everyone's noses pressed up against it. This will ensure that everyone's face is at the same distance from the camera, so they will all be sharply focused, even when you are using a wide aperture.

Alternatively, get mom or dad to hold the baby, and take a photo over the parent's shoulder. This will include them in a way that frames the baby and gives a sense of scale, but keeps the baby as the focus of the shot.

You can also buy a "lens buddy," which is a colorful toy that fits around the camera lens and makes it more interesting for a baby or toddler to look at. These are especially useful when mom and dad are in the shot, but you need to get the little one looking toward you.

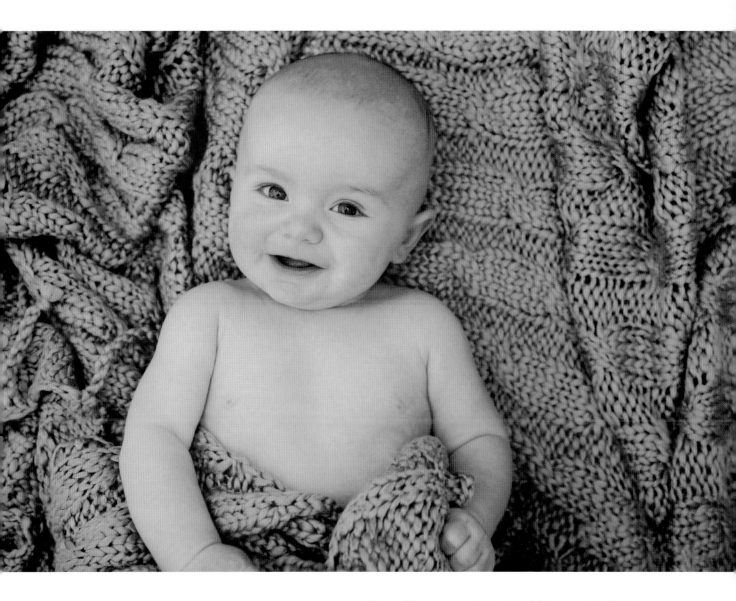

Above: Change your angle to add variety to your shots. This baby was positioned on his back on a thickly textured blanket that complemented his eye color. The photograph was taken from above, using a peek-a-boo game to produce a wide smile.

EIGHT TO TWELVE MONTHS

At this age babies can sit confidently, stand with support, and crawl, so there's much more you can do with them. However, you still need to make sure you time your shoot around the baby's naps: find out when he or she is at their happiest and plan to take the photos then.

You can still get away with nappy shots at this age, but make sure the room you are photographing in is warm enough for them to be comfortable without clothes. You may want to change the baby's outfit a couple of times for extra variety.

To get a smile, ask mom or dad to animate the baby's toys and then hold the toy near the camera lens when the baby laughs so you can quickly press the shutter-release button. Noisy toys and those with flashing lights are great for getting their attention. You can also let the baby hold the toy, before gently taking it off them and holding it just above the camera, to make them look toward the lens.

If the baby loses interest in the toys, the parents could tickle the baby and then step back next to the camera so the baby's gaze follows them. Alternatively, sing to them—babies at this age particularly enjoy songs that they know some of the actions to.

For indoor shoots, choose rooms that are light and provide the simplest backgrounds. The parents' bedroom can often work well, particularly if there are plain, white bedsheets, as these will bounce the light like a soft reflector. To add a sense of scale, you could frame the baby with mom and dad on each side.

If the baby's nursery has sufficient natural light, the cot can also make a good location. The sides provide support for the baby to hold him or herself upright in a standing position, while the bouncy surface they are standing on tends to entertain them. Some babies will think they are being put to bed once you place them in the cot, and may be upset by this, so be prepared to take them out if they don't settle after a minute or two of playing with them.

It's easier to get good shots outdoors once a child is this age, but take a blanket for the baby to sit on, especially if it's wet or muddy. Choose the blanket color carefully to complement the baby's clothes and also the look you're

Above: The bright dress worn by this baby girl needed an understated background to set it off. Use moms and dads to help you get the expressions you want by singing, making noises, and tickling the baby.

going for in the shots. Go to woodlands where trees can provide shade if it is sunny, and keep moving so you get variety in your backgrounds. If the baby is able to balance on their feet with the parents holding a hand each for support, you could include this pose in your set, as it includes mom and dad without making them the center of attention (which is also useful if they are camera-shy).

Above: Some babies will be able to stand upright using the sides of their cot to support them. This will give an image with a different look and feel, providing added variety to a set consisting of mainly seated poses.

Above: With older children you may be able to shoot outdoors. Here, we headed to a local woodland to get some outdoor shots. I brought a soft blue blanket that would complement the pastel pink of the baby's coat. This added some color to the shot, and also acted as a boundary for the subject to stay within—much like a play-mat at home. I got mom and dad to stand near me and sing to get a smile.

REVISION

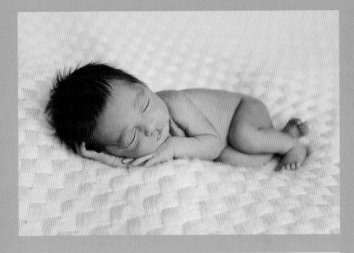

Left: Use large, textured blankets to create an infinity curve in the background of your newborn shots, but make sure you warm the room and the blankets before taking the baby's clothes off and placing them in position.

- The safety of the baby always comes first. Mom and dad need to know that they remain responsible for their child at all times and need to stay close. Find ways to remove any risk, such as positioning the baby close to the floor and surrounding the area with pillows.

- Find out the baby's current abilities from his or her parents. Your shoot will be restricted by which developmental milestones they've reached, such as whether they are able to support the weight of their own head or sit upright unsupported.

- Always time your shoot around the baby's nap routine and when they tend to be at their calmest and happiest.

- For newborns, the warmth of the room and the fabric you lay the baby on are key to ensuring they stay asleep. Gently position their hands and legs, and hold them in place for a few seconds until you feel the baby relax into the pose.

- With babies who aren't yet sitting unsupported (under six months old), change your shooting angle, the baby's clothes, and the background blankets to generate diversity in your final set of images.

- Older babies (from about six months) have better vision, so you will be able to interact with them much more. Singing nursery rhymes, making funny noises, and tickling the baby are all ways of generating smiles at this age.

- Between eight and 12 months old, most babies will begin to crawl and stand upright with support, giving you more photo options. Use toys to get their attention—holding the toy right next to the camera lens as the baby laughs can create the illusion that they are looking directly at the camera.

ISO SETTINGS

Aim: Take photographs of a baby (under one year old) using different ISO settings.

Learning objective: Understand how changing the ISO affects the camera's sensitivity to light.

Brief: Ask to take photos of a friend's or relative's baby. Depending on the baby's age, you may be able to take some shots outdoors as well as some indoors. When shooting inside, you will need to compensate for the lower light levels by adjusting the ISO settings on your camera.

With your camera in Aperture Priority mode, start with a low ISO setting (ISO 100–200). Choose the lightest room in the house and select a wide aperture such as f/2.8 or f/4 (or f/5.6 if this is the widest your lens allows). Position the baby safely on a suitable background (such as a blanket) and take some test shots. If the image is too dark, or if the camera is selecting such a slow shutter speed that the image suffers from camera shake, increase the ISO and try again. If this doesn't remedy the problem, increase the ISO even more, until the exposure is acceptable. Then, use the tips and techniques from this chapter's lesson to take some good portraits.

In the same room, gradually increase the ISO between each shot until you reach the camera's maximum setting. Then, move to a much darker room in the house and try some more shots, taking a shot at each ISO setting. Finally, head outside to a shaded area in the garden and repeat the exercise, taking photographs at each ISO setting.

Above: My 11-month-old subject was sitting grinning in her high chair when I arrived for her photo shoot, her face covered in cereal crumbs. I set the camera to ISO 400, with an aperture of f/3.2 and shutter speed of 1/160 sec., and snapped away, shooting from slightly higher than her eye level to show her front teeth.

TIPS

- Always make sure that the baby's parents are aware that they are responsible for his or her safety, and stay close at all times.

- The closer the baby is to a window, the more light will fall on him or her. The further you move away from the window, the higher the ISO you will need in order to increase the camera's sensitivity to the available light.

- As a general rule, use the lowest ISO setting that will give a suitable exposure—image quality can be impaired by digital noise when using your camera's highest ISO settings.

Left: I moved close to focus on my subject's eyes and face, using a wide aperture to minimize the depth of field. The wide aperture setting gave a relatively fast shutter speed, so I could use a low ISO setting to maintain image quality.

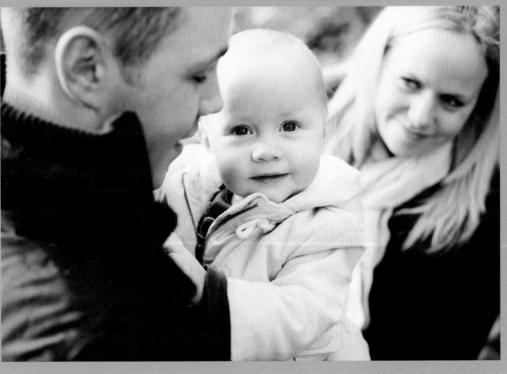

Left: If you need to use a high ISO setting, then one option is to present the images in black and white. The texture of the noise is far less obtrusive than it is in color and can even lend an image a traditional "filmic" quality. You can also add fake film grain during postproduction to enhance the effect.

ANALYSIS

Assess your images when they're on your computer to see what effect the ISO has on your images. It may help if you ask yourself the following questions:

1 How have the different ISO settings you chose affected the shutter speed that the camera selected for each image? How is the brightness of the exposure related to the ISO setting?

2 Compare an image taken at the lowest ISO setting with one taken at your camera's highest ISO setting. Zoom into each image as far as possible—how is the image quality affected by the different ISO settings? How much digital noise can you see in each image?

3 Examine your set of images as a whole. Is there enough variety in them? As babies are limited in what they can do, it's up to the photographer to create diversity by changing things like the background, angle, lighting, baby's expression and even the baby's outfit.

4 Check for strong, direct light before shooting and look out for harsh shadows in your images. Soft, diffused light will show the baby at his or her best. When shooting indoors, hang a thin white sheet over the window if the sun is shining straight into a room. When photographing older babies outdoors, shoot in shade unless there's good cloud cover or you plan your shoot for the golden hour when the light is weaker.

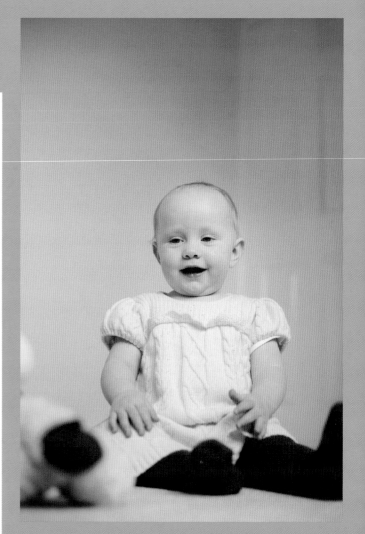

Above: Toys are an essential tool in the photographer's kit for attracting and maintaining a young child's attention. There are two things to watch out for when using them: accidentally including them in the frame (as here), or having them so far away from the camera that the subject is looking in the wrong direction. In general, it's best to hold them just above the camera lens, as this will open up the baby's eyes—when looking downward, more of our eyelids become visible and less of our eyeballs, as in this shot.

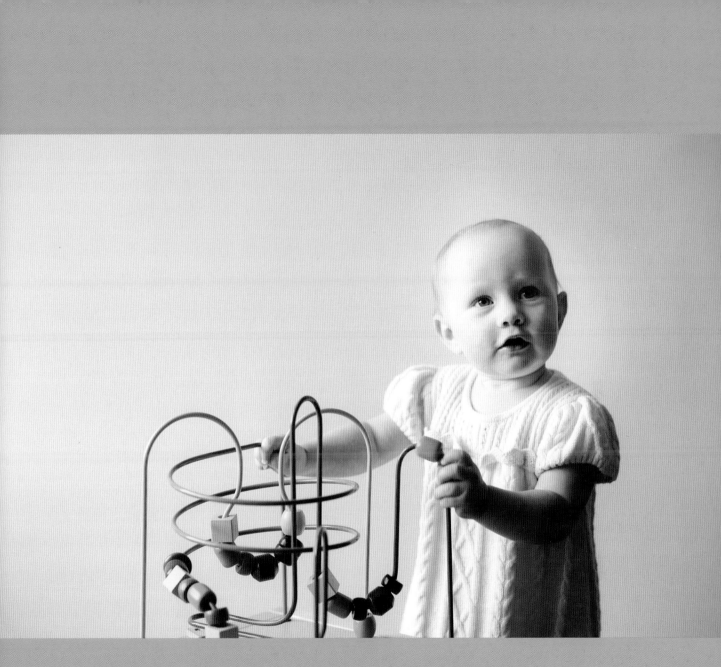

Above: There's a fine line between images that benefit from complementary, neutral tones and images that lack impact as a result of too many similar, muted colors. In this shot, the baby's skin tone and dress blend a little too much with the background wall, especially in contrast to the brightly colored bead toy. A different outfit would have helped here.

REFINE YOUR TECHNIQUE

Once you are comfortable and confident photographing babies, you can experiment with more advanced shots and techniques, such as:

- Shooting for a montage by including close-ups of the baby and elements of the room decor, as well as full-length shots. Use editing software to combine the shots, or use an online montage creator to experiment with the size and position of each image.

- Visually demonstrating the baby's scale by including an additional element in the shot, such as the hand of a parent resting on the baby's back. Alternatively, you could have the baby clasp an adult's finger—crop shots of these details show just how small the baby is.

- If the baby is not the first addition to the family, then the parents are likely to want a shot of all their children together. This is especially difficult with a newborn baby, as they are unable to support themselves. You will often benefit from giving the older child plenty of attention so they do not resent it when you ask them to hold their new sibling. Always make sure that what you are asking the child to do is well within their abilities—although they are now an older brother or sister, they may only be a toddler themselves, in which case it may be best for mom or dad to hold the baby and then ask the toddler to kiss or interact with their sibling.

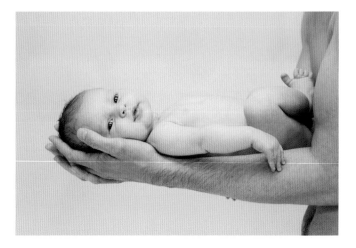

Above: This is a classic pose, where the baby is held up by mom or dad. You will need to gently turn the baby's head into position and ensure all private parts are hidden. Always take photos like these over a bed or beanbag as babies are unpredictable and safety must always come first.

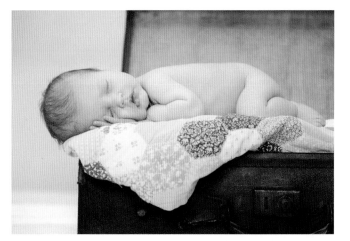

Above: Think of creative ways to include props in your images, to make them more varied and relevant to the baby's family. For instance, you could place the baby inside a suitcase, as in this shot. For older babies, you could position cut-out letters from their name around them, or have a photo of their parents slightly blurred out in the background.

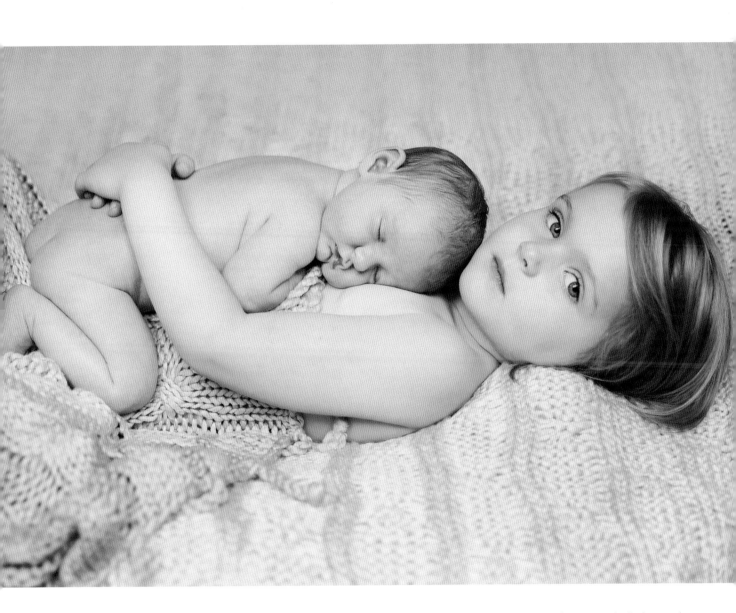

Above: This shot of the big sister wrapping her arms protectively around her new brother has a huge emotive impact. You will need to gauge the age and abilities of the older sibling, as well as their feelings toward the newborn baby, to decide whether an image like this will be possible.

TODDLERS (1–3 YEARS)

The toddler phase lies between the ages of one and three. Suddenly a stationary baby becomes a mobile explorer, with its own desires, opinions, and personality. You will need to be confident with your camera settings in order to react quickly and you will also need to be able to appeal to an age group with a short attention span.

TIMING

You can make your job easier by cleverly timing your shoot. If the toddler normally naps at 11am, for example, start taking photos at 9am, so you have at least 90 minutes before he or she begins to get grumpy. Morning shoots

Above: The bright walls and matching duvet cover in this girl's bedroom make a high impact backdrop. A window behind the camera provided some natural light, although I had to set the ISO to 640 to ensure the shutter speed was fast enough to avoid camera shake.

are likely to give you the best chance of success, and also ensure the youngster won't yet be tired out.

At this age, children are building up their immune system, which means they are often catching coughs and colds from the others at their nursery or playschool. When you photograph an ill toddler they will be fighting their way through the whole shoot, so it is better to reschedule and capture the youngster looking their best and having fun.

RESEARCH

Before getting started, find out what the toddler's skill level is, and what he or she enjoys. For example, if the youngster is just learning to count, turning counting into a game could be an effective interaction to start your shoot with. Line five toys up (they can be out of shot if you don't want to include them in the photo) and prompt him or her by asking, "How many toys can you count? One... Two..." A big shout and clap on number five will delight them. Alternatively, there may be a favorite song or a noise that makes them laugh.

Above: Let go of any inhibitions! With toddlers, the sillier you can act, the better. Singing nursery rhymes, making noises, and challenging the toddler's knowledge can lead to expressions like this one. Say things like: "What noise does a cow make? I think it goes meowwww!" and prepare to be put right!

PARENTS

Parents know more than anyone what makes their child smile—it might be as easy as a particular song, toy, or "rude" word. Parents can also play an active role during the shoot, either by standing next to the camera and calling out to their son or daughter, or by interacting with you. For example, mom or dad could move a soft toy crocodile nearer and nearer to your ear, telling the child that "Mr Croc" is going to bite you. Even straight-laced parents can do this, while the more fun-loving ones will really go overboard. The child will delight in your reaction, and you can shuffle closer to him or her in the guise of trying to get away from the threat while whispering, "Oh no, stay really still! He's getting closer!" Activities like this will give you four or five minutes to take shots before you need to switch it up and try something different.

On the other hand, some parents can do more harm than good. If mom and dad are snapping at the children to "smile at the camera" and "stop messing around," it might be worth diplomatically suggesting they step out of the room to see if their son or daughter behaves differently.

TANTRUMS

Sometimes a youngster will be reluctant to get involved and it can be tempting to plead with them. Instead, take a break, get some detail shots from the toddler's room, or take portraits of the parents together as a couple. If there

Below: Even if parents don't want to be the main focus of a photograph, they are usually happy to frame their son or daughter like this. Having mom read the book to her son provided a break in the intensity of the shoot and created an opportunity to capture a more neutral expression from the young boy.

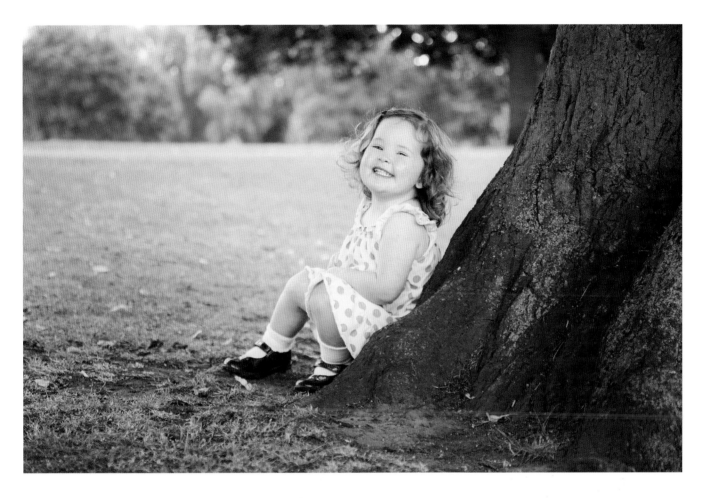

are several kids, concentrate on getting individual shots of the others. Try not to let the mood of one child affect the energy and enthusiasm everyone else may have. If you carry on and the whole process looks like fun, the child will want to get involved.

As a last resort you could agree to take five more shots then show the toddler your favorite on the back of the camera. A word of warning, though—if you use this trick too soon they'll want to see each shot you take. Make sure you stay in charge!

GETTING STARTED

It's worth getting to know the toddler before you begin shooting, so they feel comfortable in your company. Play with some of their toys with them for a few minutes before even getting your camera out.

Above: Allow the parents to help you get the smiles you want. Ask mom or dad to stand as close to the camera as possible and play peek-a-boo, sing songs, or make funny noises.

Aim to have lots of mini shoots within the time you have available, rather than expecting to shoot continuously for an hour or more. If you get 10 minutes that are magical out of each half an hour, you're doing well. Moms and dads are liable to panic if their son or daughter stops smiling during the photo shoot, but encourage them to relax, as too much pressure will make it harder for everyone!

LIGHT & LOCATION

Start in the family home, so everyone is in familiar territory. Choose a chair or sofa near a big window and ask mom or dad to read their child's favorite book to them.

After that, head out to a local wood or park where there's plenty of space to move around in and trees to diffuse any direct sunlight and provide a pleasant background.

To finish off, you could try some shots in the child's bedroom, so you capture one of the most important places to them from their childhood (with mom or dad present or within earshot in the hallway). By this stage they are likely to be used to having you around, so will be most relaxed.

Above: The colorful book spines create background interest and complement the young girl's pink dungaree buttons in this shot. Choose the brightest rooms with the biggest windows when taking photos indoors to get as much natural light as possible.

TRY THIS

• Mom and dad can tickle the toddler, staying out of shot completely or using their body to frame the shot.

• When outdoors, get the parents to stand behind you and prompt the toddler to run to them, taking the shot before they pass you. Alternatively, ask mom or dad to chase the little one, or try running toward them yourself, shouting, "I'm coming to get you!" Increase the shutter speed and use your camera's continuous focus mode to ensure the shots are sharp.

- Invest in finger puppets or use the child's favorite toy. Play peek-a-boo then tickle the parents before building up to tickling the toddler.

- Ask them to jump in a puddle or on to a "magic leaf." If they don't want to, tell them they definitely mustn't jump in the puddle or on the leaf!

- For older toddlers, pretend you have wobbly feet and are going to fall over. Children love slapstick humor, so be silly and dramatic.

- Say, "What's daddy doing?" to make a toddler look up toward their parent.

- Give the toddler a ball and ask them to throw it to mom or dad. Have the parents catch the ball and then bring it quickly as close to the camera lens as possible, so the child's gaze follows.

- Bath-time can be a fun photo opportunity when taking shots of your own kids (but not other people's). Shoot from low angles and use plenty of bubbles to preserve your son or daughter's modesty.

Above: Toddlers have pore-less skin and thick eyelashes. When they spot a bug on the floor, or are distracted by their parents' phone, this is the perfect opportunity to get in close and capture their dark lashes contrasting with their perfect complexion.

- Take lifestyle shots as well as smiling portraits. Parents will also want to remember how their child looks when absorbed in reading a book or putting together a puzzle.

- Don't be a tyrant, shouting instructions: if it isn't working, take a break for 10 minutes and then try again.

- Avoid bribery as this makes the shoot a transaction—something the toddler has to be bribed to do, rather than a fun activity that they want to do. Only ever use bribery as a last resort, when all else has failed. Even then, just let the toddler earn stickers or tokens during the shoot in order to get a small goody at the end. If you start off offering sweets for smiles, you won't be able to get any cooperation without a reward after every shot!

Above: Experiment with your camera angle, taking shots from above the toddler, as well as at their eye level. Finger puppets are a handy accessory, as they allow you to hold the child's attention and operate the camera.

- Watch out for visible nappies or knickers with girls when they're sitting down—trousers or a longer dress can help avoid this happening.

- Ensure parents are aware that they are responsible for their child's safety. They must stay close and "on duty" at all times.

REVISION

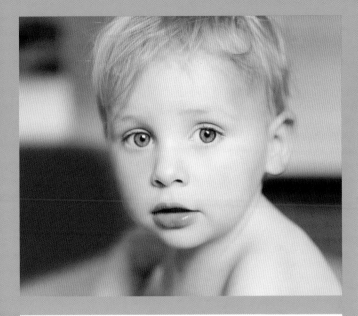

Left: The most angelic shots aren't just about the smiles—capture all aspects of the toddler's face, including more neutral expressions and those of concentration and curiosity.

- Time your shoot so it doesn't fall immediately before a scheduled nap or at the end of a busy day for the youngster. Early mornings tend to be the best, as the toddler has just had a full night's sleep.

- Ask the toddler's parents what their son or daughter enjoys, whether that's singing, silly noises, or peek-a-boo. Interact with the toddler before getting your camera out so they don't feel wary of you.

- Get the parents fully involved in the session, using the child's own toys to play little games that get them grinning. If you feel that mom and dad are affecting the mood of the shoot negatively, suggest trying some shots with them outside the room.

- Don't shout or resort to bribery. If it's not working, take a break and try again. Get some detail shots of the toddler's room or take some of their parents in the meantime. Remember, 10 successful minutes out of every half an hour is good going!

- Use all the locations available to you for variety in your final set. You could start off at the family home, then head to some parkland, before finishing off with a few shots in the toddler's bedroom.

- Use your creativity to lead a series of games and activities that will get you the expressions you want. Toddlers love to be chased, love using their imagination, and they love watching adults being silly!

- Use toys in portraits for a specific reason: for adding color, because they are beautiful old-fashioned toys, or because it is a favorite toy that they sleep with every night. Otherwise, avoid them!

SHUTTER SPEEDS

Aim: Take a series of photographs of a toddler (one to three years in age) using different shutter speeds.

Learning objective: Understand how changing the shutter speed affects the exposure.

Brief: Ask to take photos of a friend's or relative's toddler. Toddlers don't sit still for long, so this age group will give you a chance to experiment with the shutter speed and its effect on the final image. Set your camera to Shutter Priority mode and start with the toddler playing indoors or reading a book on a bright day. You may need to set the ISO in the region of ISO 400–800, depending on how much natural light is entering the room.

Start with a slow shutter speed by rotating the main control dial until you have selected a 2-second exposure time speed—this will be displayed as 2" on your camera's LCD screen. Take a shot—it's likely that the image will have a lot of camera shake and be very blurry. Increase the shutter speed to 1/15 sec. and try again. Continue to increase the shutter speed gradually, taking test shots until you have reached your camera's fastest shutter speed.

Decrease the ISO and head outdoors to experiment once again with taking images at different shutter speed settings while the toddler is playing with a toy. Ask a friend to interact with the toddler by chasing him or her. Explore which shutter speed is required to freeze the movement of both subjects, and which shutter speed records a little motion during the exposure.

Above: Despite a large window to the right of the subject, it was still quite dark for this indoor shot, so I needed to set the ISO to 640 to give me a shutter speed of 1/160 sec.

TIPS

- Always make sure that the toddler's parents are aware that they are responsible for his or her safety, and stay close at all times.

- Increase the camera's ISO setting to make the sensor more sensitive to light and reduce the shutter speed; reduce the ISO for less sensitivity and a longer exposure time.

- When using a slow shutter speed, lean against a bench, a tree, or another support to steady yourself and reduce the risk of camera shake. If there's nothing suitable to act as a support, tuck your arms close to your sides and make sure your feet are firmly on the ground, shoulder-width apart—this is one of the most stable shooting positions.

Above: I played peek-a-boo around this door edge to capture the boy's burgeoning personality. As we were both moving, I needed a faster shutter speed in order to avoid any blur, so I set 1/200 sec., again at ISO 640.

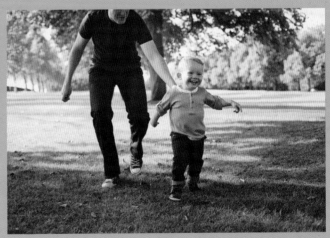

Above: My subject and his dad are both big football fans, so we took a ball to the park to play with. He had the ball at his feet and I called out to him to kick it toward me, so that he looked up toward the camera.

Above: One of the joys of photography is its subjectivity. Some people would dislike that the dad's head has been "cut off" in this shot, but this was intentional. I wanted to keep the focus on the boy, but also provide context for the grin on his face—he's happy because dad is chasing him. To freeze the action, I used a shutter speed of 1/500 sec.

ANALYSIS

With your shots safely downloaded to your computer, take a look through them to see the effect that the shutter speed has when it comes to freezing movement. There's no right or wrong here: you might like it if your subject is slightly blurred, as this could suggest "action," or you may prefer it when motion is frozen. Either way, your choice of shutter speed is the deciding factor.

1 When you adjust the shutter speed in Shutter Priority mode, the camera automatically changes the aperture settings. Look at the image data for your shots to see how the aperture and shutter speed settings relate to each other. How has the camera compensated for your use of a slow or fast shutter speed in terms of the aperture it has set?

2 When might it be more important to control the shutter speed, rather than the aperture?

3 Which shutter speed worked best for the different environments? At which setting did the toddler's movement become frozen rather than blurred?

4 Check for wary expressions in your shots. If the toddler looks unsure or uncomfortable, it could be a sign that you need to spend a little more time interacting with them first before getting started. This age group can't fake smiles, so you need to earn them. To do that, he or she needs to feel relaxed around you.

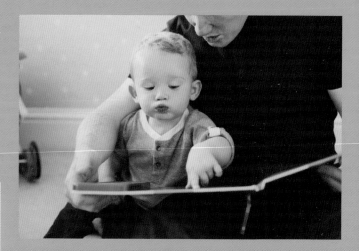

Above: Toddlers are highly expressive, and a few minutes of reading time can show intense concentration, confusion, joy, and interest. By taking sufficient shots, you will be able to pick the best expressions as some—like this one—may be funny rather than flattering! A visible toy at the edge of the frame distracts the eye, but there is enough space around the subject to crop this out in postproduction.

Above: This shot was taken in the toddler's bedroom, with his dad just out of sight and tickling him. The ISO was raised up to 640 due to the lower light levels in the crib, but a slower shutter speed was required in order to make a good exposure. This has resulted in a touch of blurred motion.

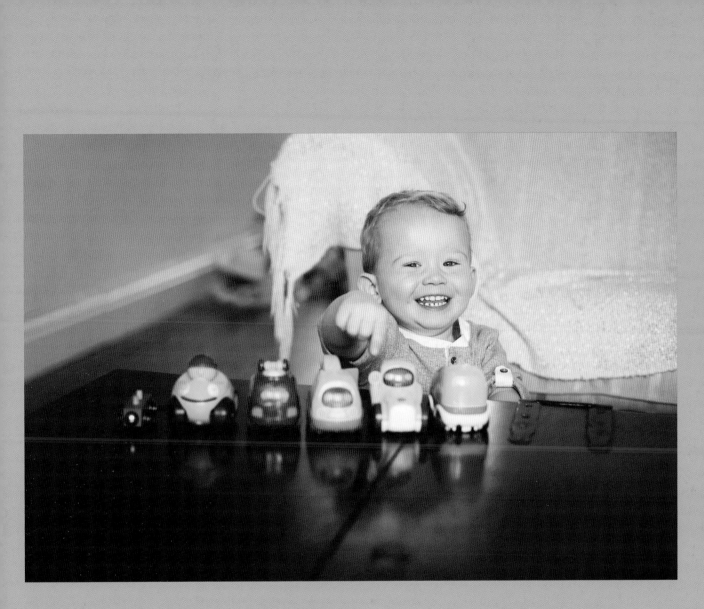

Above: The subject of this shot is learning his numbers, so we lined up some toys and played counting games. The expression is full of life, but the blurred toys in the background draw the eye. This could have been avoided by moving the toys or changing the angle the portrait was taken at, so they were excluded from the frame.

REFINE YOUR TECHNIQUE

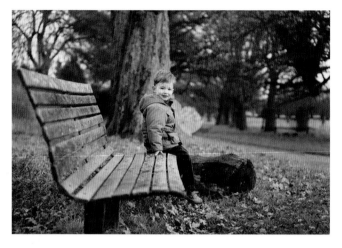

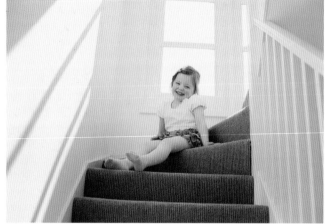

Above: Once you are more confident with your camera settings and are able to interact easily with this age group, experiment with making your compositions work harder for your images. In this shot, the lines of the bench not only draw the eye toward the young boy, but also emphasize his small stature.

Above: Make the background of your shot one of its key strengths, rather than something secondary to the subject. Here, the light on the wall echoes the angles of the handrails and the window frames the girl's head like a halo. Her outfit complements the whites and browns of her surroundings perfectly, resulting in a harmonious shot.

- Once you have mastered your camera settings and are able to build rapport quickly with toddlers; try to focus more on the overall quality of the photographs you produce, in terms of the light, location, and composition.

- Try using a flash indoors to boost the light levels on gloomy days, or when the toddler isn't close to a window. Turn the flash head so the light is bounced off a wall or ceiling for a more natural effect.

- For families with more than one toddler, challenge yourself to get a shot of them together. Get the children interacting and position them as close as possible to emphasize their unique relationship.

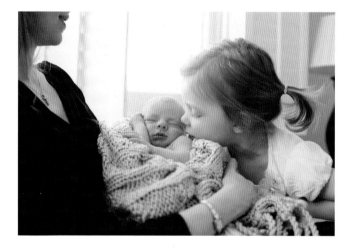

Above: Although often only a couple of years old themselves, toddlers instantly become the "older child" when the family has a new baby. The challenge for the photographer is to capture both siblings together. Having the baby held securely by a parent and asking the toddler to lean in for a kiss is one way to achieve this.

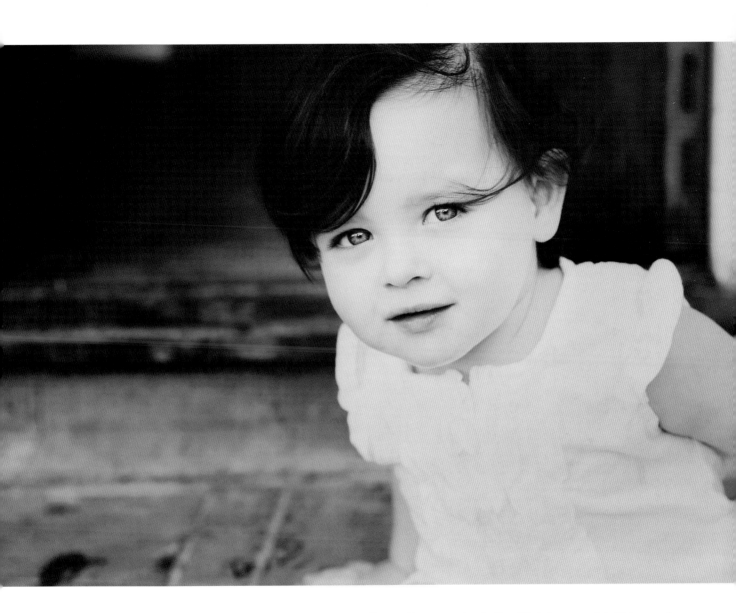

Above: Use your postproduction skills to turn a good shot into a great one. In the original version of this image, mom's bright shoes were visible on the step in the background and the young girl's skin was less even. Tidying up these details, converting the image to black and white, and boosting the contrast has transformed the shot.

CHILDREN (3–12 YEARS)

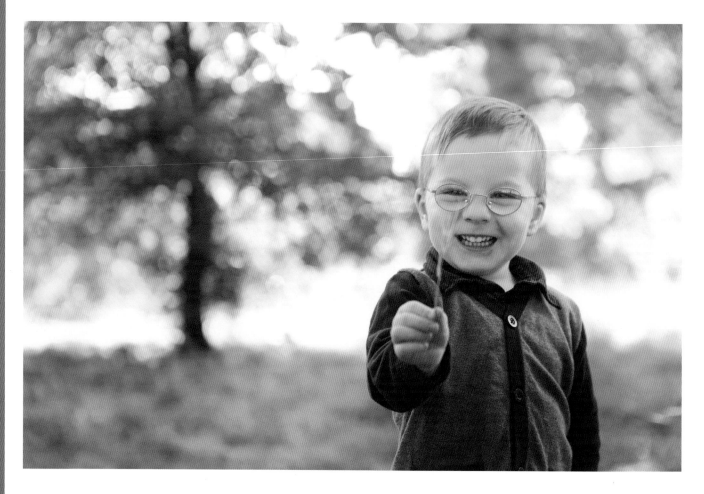

Are you feeling energetic? Well you need to be if you want to get the best from children between the ages of three and 12, as you have to capture (and hold) their interest and attention, while staying in control to get the shots you want. Although it's hard work, this can also be the most fun age group to photograph as children have vivid imaginations, possess unparalleled zeal, and love to play. Get to know them and use your creativity to engage them by keeping your shoot relevant and fun.

Above: Genuine expressions like this one are a result of building a rapport with a child so they are relaxed around you. Then you can interact with them, using whatever is available as a prompt for playful dialog and fun activities.

GET TO KNOW YOUR SUBJECT

If the child you're photographing isn't your own, it is a good idea to spend a little time finding out what their interests are. If they have a favorite book you could build a rapport at the start of the shoot by reading it with them. If you discover fairies or dinosaurs fascinate them you could look for "fairy homes" or "dinosaur tracks" in the garden, whispering throughout for dramatic effect.

If you get this part right, the child will feel that you are on their level, will relax around you, and will be more willing to follow your prompts later on in the shoot. This is especially important when a child has a new sibling and is suddenly the "big" brother or sister. They are likely to have experienced a decline in the amount of attention they receive, and giving them 100% of your focus when you first arrive will pay dividends later.

KEEP IT FUN

If you allow children to be silly you're more likely to get the shots you need. For example, you could ask the child for

Above: Children actively pursue fun, whether that means interacting with others or using their powerful imaginations as a basis for play. Allow them to be silly and you will get the shots and expressions you want.

their best "angry face," "surprised face," or "silly face." Then, when you ask for their best "happy face," you're more likely to get the expression you're after—the child is having fun and this last request is all part of the game.

However, don't expect to shoot non-stop for a whole hour or longer. Instead, split your shoot into "mini sessions," fitting several activities into a 10-minute shooting period and then taking a break before starting the next session.

This will ensure your subjects have the energy to fully enjoy each part, enabling you to capture the best expressions.

You may also find you get great results if you allow the children to do things they're not normally able to do, such as jump on their bed. This way, having photographs taken becomes something to look forward to, rather than a time when they are bossed around or shouted at.

When capturing individual shots of children, get their parents and siblings to stand next to the camera lens and help you get the expressions you're after. Sometimes, having a family member poke their tongue out or wiggle their bum is all that's needed to send a young child into fits of laughter.

Above: Having one arm around his brother gives this shot a dose of warmth and affection that would otherwise be lacking if they had been merely standing next to each other. Pretending to coat his hand in "invisible glue" ensured the older boy kept his hand on his brother's shoulder.

"STICKING" SIBLINGS TOGETHER

Parents love shots of their children showing each other affection, whether it's hugging, holding hands, or simply putting an arm around each other. Sometimes, though, the kids are less keen to get—and stay—close to one another.

When you are starting a shoot with siblings, take a moment to see what the relationship is like—how close do they stand together when you ask them to hug? One trick

Above: An angelic expression of curiosity was captured perfectly here. Asking, "Can you see bugs on that leaf? Sometimes I think fairies live on leaves, can you see any?" appealed to the child's imagination and held her attention on the leaf long enough for me to take this shot.

worth trying with more reluctant siblings is pretending to spread "invisible glue" on the children's hands or cheeks before "sticking" them into place. Kids' imaginations are so strong that this can often be sufficient to keep them together long enough to take a photo. It also gets them used to the idea that the shoot might need them to be fairly close together. "Invisible glue" can also be used to keep fidgety hands and feet in place for posed shots!

MULTIPLE MOODS

Try to capture all of a child's expressions, not just the smiles and grins. Quite often, kids' faces are at their most angelic when they are absorbed in something—looking for bugs on a log, reading a book, or just gazing out of the window. A whole set of images with the same expression risks becoming monotonous and—particularly with quieter children—doesn't necessarily reflect their true personality at that age. Equally, a child laughing, but looking off-camera toward their parents can be more powerful than a straight-down-the-lens smile, as there is often visible love evident in their expression when interacting with their own family.

OLDER CHILDREN

Children at the upper end of the age range often want to look like teens, rather than kids, in photos. By this age they have usually been exposed to movies, music videos, and magazines, and they aspire to look like the moody pop stars and fashion models they see. Allow them to choose their own clothes and include the kind of shots they want. You are more likely to get the kind of shot their parents will want—where the child is smiling and looks their age— if the child feels that you are on their level and have already taken some photographs that they will want to show their friends. Find out what is currently on-trend in the mainstream media in order to understand the images that will appeal to this age range (ensuring you avoid anything remotely risqué).

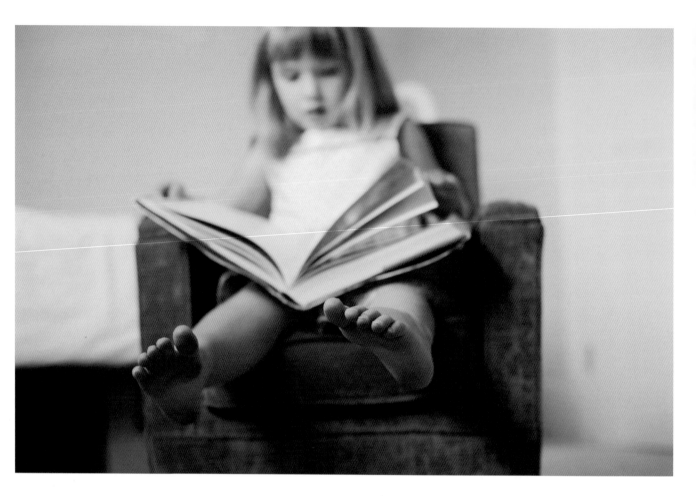

SHOOT A SERIES

A single image shows a moment in time, whereas a series of photographs can tell a story—a day at the park, for example. Consider how images can be combined with others to form a montage, so that instead of thinking one shot at a time, you are mentally putting together sets of three or nine photographs. Remember your earlier shots and find ways to echo them.

Montages can feed your creativity—when more than one shot will be displayed, there's more space for the silly or unusual, such as images of the kids pulling faces, close-ups of linked hands, and action shots. Also, when you have more than one child to photograph, a montage can be a backup option if you're unable to get a strong shot of all the children together.

Above: Shooting a series of images for a montage gives you greater freedom for creativity. A shot showing an unusual perspective like this might not make it onto the wall on its own, but it works brilliantly as one of a number of images displayed together.

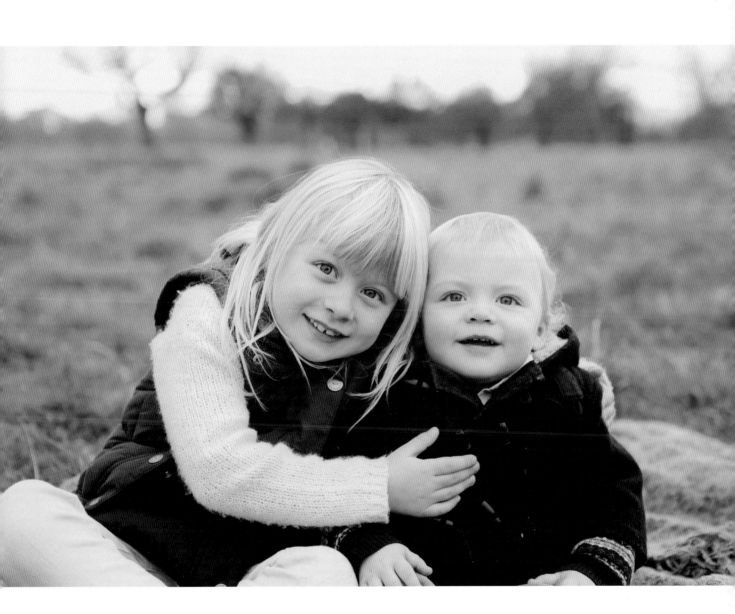

Above: With children of different heights and ages you will need to find ways to get their faces as close together as possible for at least some of the shots. Seating both the children for this shot and asking the older sister to lean in and hug her younger sibling helped ensure their heads were next to each other.

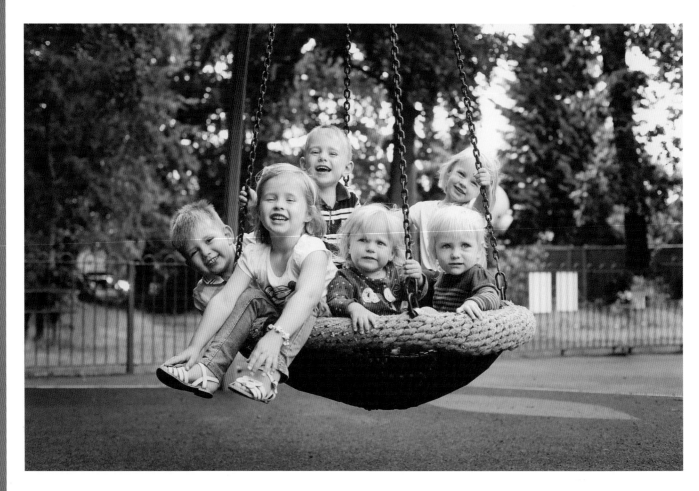

TRY THIS

- Children love slapstick humor, so when standing on a log, bench, or bed, for example, pretend you have wobbly feet and are about to fall over.

- Use what's around you as a basis for fun and interaction. Ask a child to jump on a "magic, crunchy leaf," saying, "I think this one might go pop!"

- Engage the child's imagination. A patch of grass in the local park could become an island in the sea and you could be a scary shark, circling around the island.

- Ask young children to look for bugs and capture their expressions of concentration.

Above: The local playground was the ideal location to photograph these grandchildren. The large swing seat helped to keep them all in one place for the group shot—no mean feat with six young kids!

- Mark out three places for the children to start running, stop running, and start running again, with the intention of capturing their expressions at the point they stop. Build up their anticipation beforehand by prompting, "Are you ready? Are you sure?" before shouting "Go!"

- Take small cars/dolls to the park and hide them in the locations that have good lighting and backgrounds. Then challenge the children to find the "treasure," positioning yourself at the best angle to capture the action, and whoop and holler when they find the toys.

- Think carefully about possible locations. You could start off with a shot of the child sitting on their own bed by the window, where they will feel most relaxed, then move outdoors so you have more space and a greater variety of backgrounds.

- Lighting will affect your location choice. If you are shooting indoors, choose the room with the most natural light and shoot next to a large window or just inside the front or rear door. If you are shooting outside, make sure bright sunlight isn't making your subjects squint.

- Get the more traditional "smiling at the camera" shots first, so you can increase the momentum as the shoot progresses—if you start your shoot running around it will be harder to get sedate seated shots later on. Plus, if the kids aren't familiar with you, they will be more intrigued by you at the beginning and may be more agreeable!

- Avoid bubble makers. At this age children go crazy, chasing the bubbles around in a way that's random and unpredictable. You need to be in control of the things that make the children have fun in order to get the shots you need.

- Suggest where the child sits when taking breaks between activities (choosing the light and location cleverly). This may give you an opportunity to capture images of him or her relaxed and at rest, which will complement your more energetic shots.

- With siblings, set the scene for interaction then let it happen. This will give you time to change your settings, check the image preview, experiment with angles, and have a break.

Above: It used to be received wisdom that when photographing children you should always get down to their eye level. However, shots taken from a higher angle can be incredibly flattering, as they really open up a subject's eyes. In this shot, the effect is enhanced as the blue cardigan the girl is wearing matches the color of her eyes.

- Get siblings to hold hands and jump. By holding hands, they will be closer together in the final image.

- Older boys love toilet humor. Before you start, check with the parents what "naughty" words the child is allowed to say and save them for the end of the shoot, by prompting "Let's say bum!" for example.

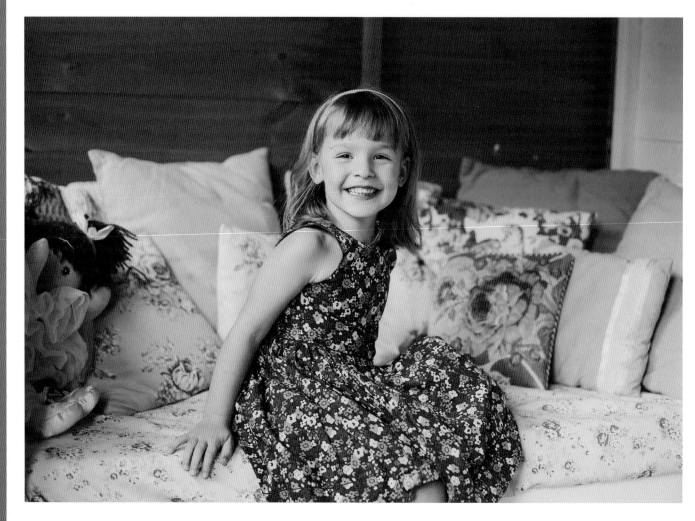

Above: Children love silly humor, so bring out your internal clown to make them laugh. Pretend you have wobbly feet and are going to fall over, or that you are scared of certain words or noises and then get ready to react in an overly dramatic fashion!

REVISION

Left: Choose your location carefully so you have a suitable background and flattering light, as this will free you up to concentrate on interacting with the child. This playhouse provided an attractive backdrop that not only complemented the nearby trees, but also provided shade so that the boy's face was shielded from direct sunlight.

• Be playful, energetic, and fun: you can't bore, bribe, or bully a child into having a good photograph taken!

• Get to know the child first so they feel relaxed in your presence and you learn what interests them. This way, you can tailor your approach to include the kind of things that appeal to them, whether that's pirates, fairies, dinosaurs, robots, or something else.

• Appeal to a child's imagination to get the shots you want. For example, coat their hands with "invisible glue" to get them to stay in place, or pretend that a forest is filled with magical animals to get them to start exploring.

• Lead the action by setting up games involving running, jumping, or finding hidden treasure you have put in place specifically for them to find.

• Capture the more serious and curious faces, as well as the smiles.

• For older children who want to look like teenagers, aim to get a mix of fashion-conscious shots that will appeal to the child and younger-looking playful shots that will appeal to their parents.

• Think about how a series of images could be combined into a montage.

METERING MODES

Aim: Take photographs of a child (three to 12 years in age) using the three main metering modes.

Learning objective: Understand how different metering modes impact on the exposure.

Brief: Find or borrow a young model (with their parents' permission, of course!) to pose for you as you explore your camera's different exposure metering modes. On most DSLRs the options include multi-zone, center-weighted, and partial or spot metering.

Whenever the camera is making some of the exposure decisions for you (such as which aperture and/or shutter speed to use), it will rely on the metering mode to determine which parts of the frame to concentrate on. For this project, you are going to explore how the metering modes impact on the final image.

Start off indoors with your subject next to a window. Take the same shot using each of the three metering modes, so you can compare them later. Then, find an area indoors where there are multiple sources of natural light (a window and a door, for example) and position your subject so that they are backlit by one of them and front- or side-lit by the other. Again, take three shots, using the different metering modes. It's a good idea to use the metering modes in the same order each time, for an easier comparison later.

Next, head outside and find a light-toned background, such as a white wall or a bright, overcast sky. Take a shot with your subject in the center of the frame using each of the metering options, then take the three shots again, but this time with your subject off-center. Then, repeat the exercise, but this time use a dark-toned background, such as a brick wall or painted door.

TIPS

• If you want to meter from an area of the frame that is off-center, you can use your DSLR's auto exposure lock. This "saves" the exposure reading when you press the shutter-release button down halfway, allowing you to recompose your image. To use AE-L, position the focusing/metering box in the viewfinder over the part of the image you want to meter from, hold down the AE-L button (or just press it, depending on your camera model), then re-frame your image before pressing the shutter-release button down fully.

• Remember that the camera's metering system aims to achieve an exposure that would render an average, midtone gray correctly under the lighting conditions. So, when using spot metering, make sure that the part of the frame you are metering from contains a midtone.

Above: Backlit scenes can fool the camera into underexposing, so you may need to use your camera's spot meter. If you do, be sure to meter from a midtone (such as your subject's skin) so the shot is exposed correctly.

Left: This is a fairly average scene in terms of contrast—there are no extreme areas of light or dark tones, so the camera's multi-zone metering copes. I used the "invisible glue" technique to get one of the boys to keep his arm around his brother for this shot.

Above: Having lots of room above the subjects gives a sense of space and light that is very popular in contemporary photography and provides variety in the final set. However, this would fool the camera's center-weighted metering pattern, as the subject is very small in the frame and is off-center. Using multi-zone metering ensures that the camera prioritizes the area of the frame that has been focused on.

ANALYSIS

Review your pictures on your computer, with your image-editing program's histogram on screen. As you analyze your shots, note how the histogram looks when you get things right. Most cameras enable you to call up a "live" histogram while you shoot (or during playback), which you can also use as a guide to checking your exposures.

Above: Watch out for changing lighting conditions when outdoors. The light on the center of the twins' faces is perfect, but the sun has just broken through the cloud, producing a line across the boy's forehead at the top right of the shot. Sun-kissed highlights can work beautifully in the background of a portrait, but here the lighter ground at the right is distracting. The shot would be stronger if it had been taken under full shade or if the clouds were fully diffusing the light consistently across the whole shot.

1 Which metering mode produces the best exposure when the subject is lit from the front or side? What about for a backlit subject?

2 How was the image affected by positioning the subject off-center when shooting in each of the metering modes?

3 Watch out for unwanted blur caused by movement. When you are photographing active children, you may get shots where their faces aren't sharp. To counter this, you need to increase your shutter speed and you may want to use your camera's continuous focusing mode so you can pick the best action shot.

4 Check for variety in your final set: have you got a mix of portrait/landscape compositions, action/still shots, individual/group shots, happy/natural expressions? Change your angle regularly while you're shooting so that each image looks different. This is especially important when you are photographing one child on his or her own—you could go to a couple of different locations for maximum diversity.

5 Are the children's eyes sharp? This is especially tricky when they are moving around. Use a smaller aperture so more of your image is in focus, and make sure that the focus point is over the subject's eye when you press the shutter-release button.

REFINE YOUR TECHNIQUE

- Even if mom and dad are adamant they don't want to be in the photos, they will often be willing to have just their legs or arms showing. This gives a sense of scale: we are all aware of the average size of a full-grown adult, so we get a better idea of the child's height when we can see that they are roughly "waist high" compared to mom or dad. It also gives variety to your set when the parents frame the child, as it adds some detail to the border of the image.

- Don't be afraid to crop into the forehead of your subjects. This can aid your composition, helping to place the

Above: Use the parents to emphasize their child's small stature with creative framing. Here, the son's parents appear too big to fit in the frame. Notice how the camera's angle—positioned at the child's eye level—exaggerates the effect, with the photo reflecting his view of the world.

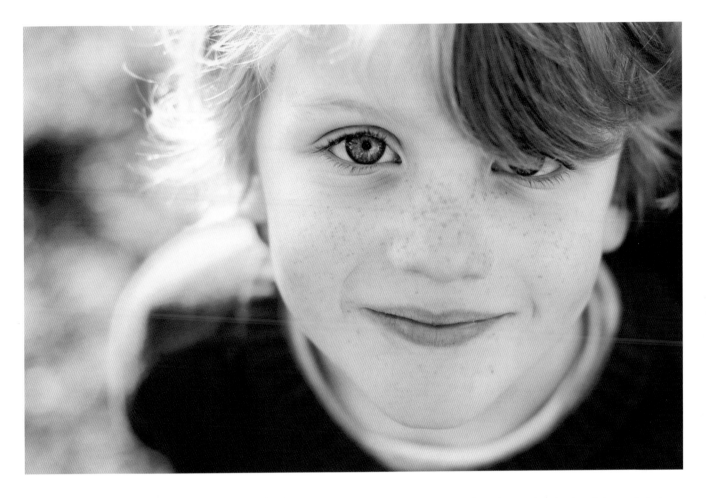

Above: Use bold crops for high-impact shots of a child's angelic features. This can be done in-camera or during postproduction. This shot was originally a portrait-orientation bust shot, but was cropped in Photoshop and converted to black and white to produce a completely different image.

subject's eyes on one of the key points in the image, according to the rule of thirds. It also means the photo will have a higher impact, even when shown at a smaller size, because the frame is filled with the subject's face.

• Nothing gives your images life and dynamism more than showing movement, whether it's hair lifted by the wind, leaves being thrown into the air, or children running toward the camera. You can choose whether to "freeze" motion or exaggerate it by adjusting the shutter speed.

TEENAGERS & ADULTS

With this older age group you'll have the luxury of working with subjects who are able to follow instructions and hold a pose. Your job is to help them feel relaxed in front of the camera and know how to flatter them in order to get images they'll love.

START RIGHT

Ask teenagers and adults to look for photos they like beforehand and discuss what they like about them—is it the model's pose or expression, the lighting, or the composition? This will give you an idea of the style of image that will most appeal to them. It is also a good idea to find out what they want to use the images for, so you can take that into consideration as well. For example, a shot destined for a social media web site may need to fit into a square frame once uploaded, so a close-up may not work if there's not enough space to crop it without cutting further into the subject's face.

Before you begin, take some time to explain what you're going to ask him or her to do. People are most nervous when they don't know what to expect, so make it clear that while some of your directions might seem strange, there won't be anything difficult or impossible.

Finally, a lot of people hate photographs of themselves because they are disappointed by them. Reassure your subject that you are going to use a range of tools—including lighting, posing, and camera angles—to help them look their best. When you take a great shot, show them, as this will boost their confidence, which will make them look and feel even more relaxed.

TEENAGERS

Teenagers—and older children—need to know that you aren't going to be like mom and dad with loads of "dos and don'ts." They have to believe that you are not another authority figure telling them what to wear and to smile more, and that you won't embarrass them by asking them

Above: As we get older we often become more self-conscious. Adults are also less used to being in front of the camera than children, so explain what you're going to do before you start and reassure your subject as you shoot to help them relax.

Above: Treat teenagers as adults, not children. Let them choose what they want to wear and discuss potential locations with them. Urban cityscapes are often more suited to shots of this age group.

to do uncool things. Depending on their relationship, you may need to ask the parents to give you some space, so the teen's behavior isn't affected by their parents' presence.

Allow teens to choose their own clothes and include the kind of images they aspire to, which are likely to be similar to those of fashion models or music stars. The parents will want photos where the teenager is smiling and looks their age, not older, but you are more likely to get these if you get the ones the teenager wants first.

Try to match his or her energy levels, but be aware that you will need to adapt your approach when photographing a giggling 13-year-old girl compared to a super-cool 19-year-old boy. Find out what their interests and hobbies are; you might want to photograph them strumming their guitar, walking their bike toward you, or dressed in their football kit to make the images more relevant and personal. Offer them the option of changing outfits to give a different feel to the shots or to suit the background location better.

Think about what locations would suit the style of image you are aiming for. Teenagers tend to want to be urban and current, so are less suited to woodland shoots. If you speak to them about the kind of backgrounds that suit portraits beforehand, there's a good chance they can point the way to some suitable locations in and around the area they live in.

Remember that this is an age where hormones rocket and confidence plummets—reassure them throughout the shoot that they look good and always ask if they would like any skin blemishes tidied up.

POSING

When you point a camera at a teenager or adult they tend to do one of three things: panic, pull a funny face, or perform an over-dramatic pose. Generally, in portrait photography you want your subject to look and act naturally, with a pose that appears flattering, but not forced. To do this, you need to give him or her something to do, whether that's walking toward the camera, leaning on a

Above: To make your subject look as natural as possible, ask them to sit down in a way that feels comfortable and normal to them. What feels right to one person may not feel right to another, and will therefore look more awkward. If in doubt, let your subject choose a pose then "tidy up" their arms and legs as necessary.

Above: In portraits where your subject is looking away from the camera, try not to let their nose overlap the cheek line, as this will exaggerate its size. Instead, ask your subject to turn their head slightly toward you so the edges of his or her nose are within the edges of their face, as in this shot.

fence, or sitting/lying on the floor. Ask them to do this in a way that feels comfortable and natural to them, then adjust any aspect of the pose that doesn't look quite right.

As a general rule you should never have both the subject's arms dangling redundantly by their sides. Either hook their hands in their pockets, place one hand on a hip, or get them to loosely hug their knees if they're sitting on the floor. For close-up shots of women, you can ask them to put one hand on or near their face or hair.

Be aware that faces are asymmetric and most people prefer one side to the other, so make sure you capture shots

showing both sides. As with other age groups, capture a range of expressions and get shots with the subject looking both toward the camera and away from it.

Get a range of crops in your final set, starting with full-length portraits, as it's less intimidating than having a camera in your personal space when you're nervous anyway. Then move gradually closer to get three-quarter length shots, bust shots, and crop shots of each pose. Each time your subject is in place, move around them to explore which angles look best and interact with him or her to get a range of expressions.

TRY THIS

- When you're ready to take a shot, give humorous directions to make your subject smile and generate a range of expressions. Your aim is to make them forget that they are nervous. Examples might include: "Look up at that streetlight and give it some love," "Look at me like you just walked in your house and saw Brad Pitt standing there," or "Look as though you're deep in thought about chocolate"—the more bizarre, the better!

- For a close-up shot that flatters nearly everyone, find some soft, even light (in shade or just inside the front or rear door of a house, for example) and seat your model so you can shoot from about 45-degrees above their eye level. Use a wide aperture and focus carefully. This angle works because the subject's eyes are the center of attention.

Above: When you are being photographed, any silence is deafening. Constantly interact with your subject to make sure they feel relaxed, exhibit genuine expressions, and don't have too much time to worry about how they look—keep reassuring them that they are doing great.

TIPS

- Keep talking. Long periods of silence give a person too much time to worry about their appearance, make their expression look forced, and get bored. Remember, it's "camera, lights, action" for a reason—get your settings and scene right before posing people.

- Look out for things they might want changed and check for any hair that's out of place, an eyelash on their cheek, or sleep dust in their eyes. A few seconds to fix these things will save you having to edit them out of every photo during postproduction.

Above: If your subject looks very tense, ask them to fill their cheeks with air and then blow it out slowly. Not only will this relax the mouth, it often makes him or her laugh. Use techniques like this to get genuine, relaxed expressions showing your subject at their best.

Above: Pay attention to details, such as matching the colors worn by the same subject to a single color palette. Here I chose a predominantly blue palette for added impact. This color choice was an intentional one, to complement the subject's eyes.

- Try taking some portraits indoors next to a large window (hang a thin, white sheet up if direct sunlight is coming through it). Position your subject and then turn their head so there is more shadow on the side of the face that is closest to the camera. This is called "narrow lighting" and will make them look slimmer.

- Ask your subject to turn to one side and then slowly turn their head right round to the other side—there will be a "sweet spot" where they will look most photogenic.

TIPS

- When taking shots with the subject facing away from the camera, ensure the nose doesn't break through the cheek line, as this will make it look bigger.

- Make sure you're aware of what is on-trend in movies, music videos, and magazines. Those are often the kind of images that teenagers will aspire to.

- For more tightly cropped shots, ask your subject to hold a reflector just out of shot beneath their chin and angle it toward their face. This will bounce light that lightens their eye sockets and the shadows under their nose.

REVISION

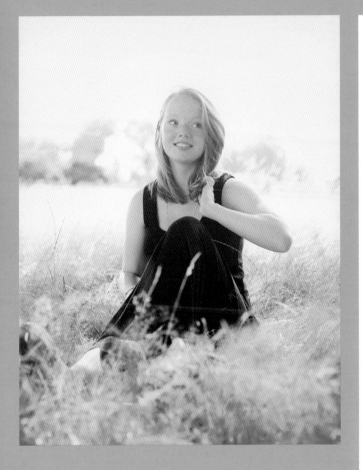

Above: Give your subject something to do so they appear more relaxed. When photographing women, asking them to put a hand on or near their face or hair can get a shot that looks candid and unposed.

- Before you start, explain what the shoot will be like so your subject knows what to expect. Teenagers and adults often hate photos of themselves, so reassure them that you will use your skills to create flattering portraits that they will be pleased with.

- Get your tone right with teenagers: although it won't work if you try to "be cool," you don't want to be another bossy authority figure either. Treat them with respect and more like adults than children.

- Tiny changes to the position of the subject's head can make a big difference. Slight tilts of the head can make your subject appear more natural, while changes to the direction your subject is looking in can alter the feel of the shot. Capture both sides of the face, as people are slightly asymmetric and often have a preference for one side over the other.

- Start with full-length shots so you are further away from your subject. This is less intimidating than having a camera in your face straight away.

- Find light-hearted ways to interact with your subject and generate a range of expressions. Use bizarre and humorous directions to make them smile.

- Always include at least one shot from slightly above the subject's eye level, angling the camera down toward them. This flatters almost everybody, especially when the lighting is soft and even.

- Putting your subject at ease comes before all other concerns. Keep talking and reassuring them that they look good and are doing great. Your ability to build a rapport will determine whether you get successful portraits or not.

FOCUSING

Aim: Take photographs of an older subject (over 12 years old) and experiment with focusing methods.

Learning objective: Understand the importance of focusing accurately.

Brief: Ask a friend or willing teenager to pose for you. Set your camera to Aperture Priority and dial in a wide aperture such as f/2.8 (or f/5.6 if this is the widest your lens allows). This will give a lovely out-of-focus effect to areas of your portrait that are farther away from your focus point.

Your camera doesn't know which part of the image you want to focus on, so by default usually picks whatever is closest to the camera or most central in the frame. If you want to include foreground elements in your shot, or if your subject is off-center, the camera may not choose the right area to focus on. If you are using a wide aperture in order to have areas of the image blurred out, then it is especially important to focus accurately, otherwise the key element of the shot—usually the subject's eyes—may not be sharp.

There are three ways you can control the focus. The first is to focus manually, and twist the lens barrel until the subject's eyes appear sharp in the viewfinder. Secondly, you can ensure the subject's eyes are in the exact center of the frame where the autofocus area is by default. Then, when you press and hold the shutter halfway down, the camera will focus on the central area and you can recompose your image if you need to before taking the shot. The third option is to manually select which of the focus points you want to use (using the DSLR's arrow keys to choose the one that will be over your subject's eyes).

To explore these options, place your subject in front of a simple background and compose a full-length shot so they are at the center of the frame. Try each of the focusing options—manual focus, central autofocus, and manually selecting a focus point. Repeat this process, but with your subject off-center. Now find something to photograph your subject through—a gap in foliage or some railing, for example—and take some more shots using each focusing method. Again, try this with your subject in the center of the frame and off-center.

Next, seat your subject and shoot a close-up from your standing eye-level (preferably using a 50–80mm focal length). Again, try each focusing method in turn, aiming to get the subject's eyes in sharp focus.

Finally, take some shots using each focus method in low-light conditions—indoors, late in the day perhaps, or under thick tree cover on an overcast day, for example.

TIPS

- Before your shoot, practice focusing on an area within the frame, holding the shutter-release button down halfway, and recomposing your shot until you find this quick and easy to do.

- To enable manual focus, look for a focus mode switch on the lens barrel. Remember to switch this back when you want to use autofocus again.

- When your subject is facing the camera, both eyes should be sharp. When your subject is angled to the camera, aim to have the eye closest to the camera as the sharpest point in the frame.

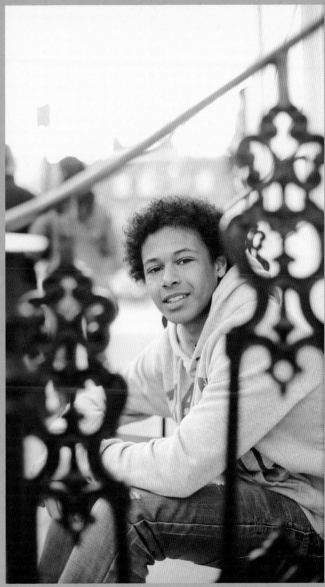

Above: People often prefer photos of themselves looking serious, as the cheekbones are less clearly defined when we smile. A range of expressions also adds variety to the final set so I asked my subject for his best moody stare for this shot. I chose an autofocus point that was positioned over his eyes.

Above: I stepped behind a parked car and photographed over it, including some of its roof at the bottom of the shot. This adds additional color and gives the image an urban feel. However, foreground elements can confuse the camera's autofocus system, so I used manual focus to ensure that my subject's face was sharp.

Above: As we passed these ornate railings on either side of a set of steps, I asked my subject to sit on the steps and then shot through the railings so they framed his face. The camera's autofocus will almost certainly hunt back and forth in a situation like this, unsure which part of the image it should focus on, so switching to manual focus is a much better option.

ANALYSIS

Focusing accurately is critical in portrait photography, so download your project images to your computer and analyze them to see which focusing method is most effective in which situation. The following questions will help you assess your photographs with a critical eye:

1 Are the subject's eyes the sharpest point of every image? If not, try to identify why the area in focus has been chosen: was it closer to the camera than the subject, or did the camera struggle to find an element to focus on?

2 What focusing method best suited an off-center subject in each of the situations?

3 Which focusing method was most effective in low-light conditions?

4 How did each focusing method compare in terms of speed? In which situations would you want to use the different focusing methods?

5 As you're working with an age group that can stay still for longer, use the opportunity to check everything before you press the shutter: is the composition as strong as it could be? Could a different angle work better? Is the lighting flattering and/or atmospheric?

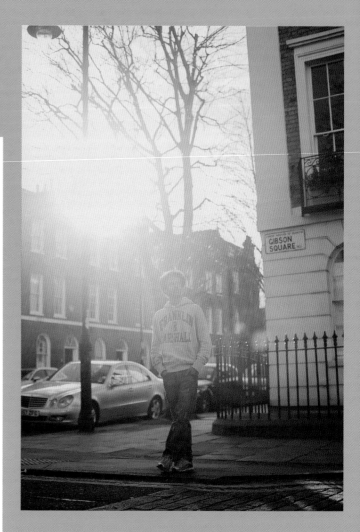

Above: The light and location can make or break an image, especially in urban shoots where there's often a lot going on in the background. Watch out for your subject getting lost in amongst it all. Here, the flare overwhelms the image.

Right: The longer someone is asked to hold a smile, the more false it looks. In this shot the mouth is smiling, but the eyes are not. It is better to get your camera settings sorted, or wait for people in the background to leave the frame, then interact to prompt a fresh, genuine smile before quickly releasing the shutter.

REFINE YOUR TECHNIQUE

- As your confidence in your camera skills and creativity grows, you will find you can head out to an unknown location and take advantage of the backgrounds you come across. Sometimes, if you have very specific shots in mind, you may not notice that the lighting on the day is particularly suited to a different angle or location than the one you had planned. Light creates the atmosphere in portraits, so if you're blessed with sunlight during the golden hour, make use of it.

- Start to consider your images as a set, analyzing them for variety: aim to capture one of each pose and expression as both a full length and a closer crop. Repeat this for the different outfits and locations in order to provide your subject with a complete portfolio of images.

- Pack a flash and head out after dark, using the flash off-camera to illuminate your subject. You can either use a wireless trigger to fire the flash, or your on-camera flash (although this will introduce another light source). Experiment with balancing the flash with ambient light such as streetlights, or making it more or less dominant by adjusting the shutter speed on the camera.

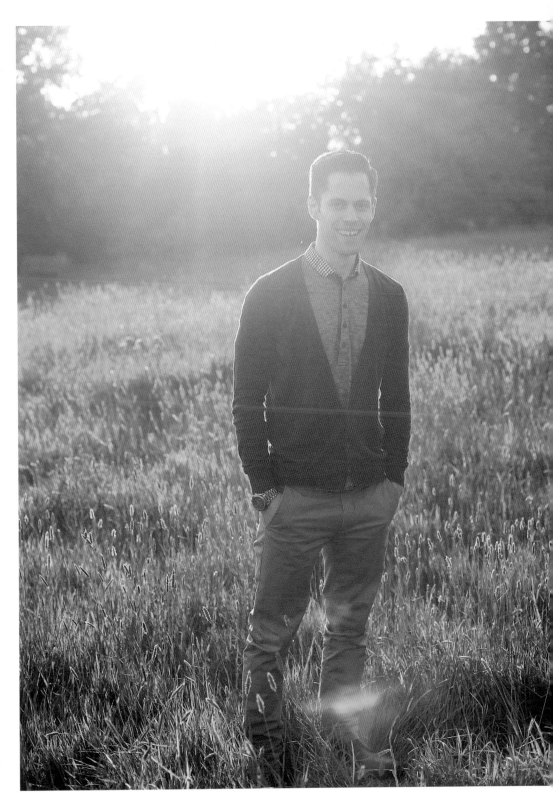

Left: These shots were taken within a few seconds of each other, showing how you can work quickly, but effectively to get two portraits that feel very different. Just by asking the subject to look down, the shot becomes more thoughtful and mysterious, while also giving you a chance to capture the subject's long, feminine eyelashes.

Right: Capture a mood, not just a mug-shot. In this image, the lighting, pose, location, and expression come together to form an image reminiscent of warm and hazy summer days.

COUPLES

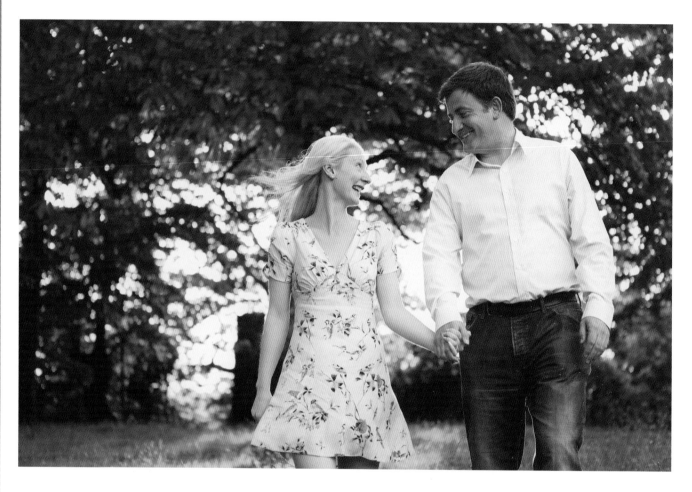

Couples may want to celebrate an engagement, prepare for a wedding shoot, or simply have images to capture a time when they were just partners—before they became parents, too. In this situation you will need to feel confident about directing two adults and use your posing, lighting, and interpersonal skills to get romantic shots that show two people in love and at ease with one another.

PRE-WEDDING SHOOTS

Couples often have photos taken as part of pre-wedding preparations, usually between two and five weeks before their big day. This gives them a chance to become more

Above: For a relaxed-looking pose ask the couple to walk toward you while they hold hands and chat to each other. In this shot, the genuine smiles of the couple as they interact creates an image that looks natural.

relaxed in front of the camera, and it is also an opportunity for them to visit their venue with the photographer in order to scout out potential locations for shots. Afterward, the photographer can show them the images taken and find out what sort of shots appeal to the couple.

If you are preparing for your first wedding shoot, visit the venue ahead of time so you can try out your settings and note where the light falls, where you can find shade, and

Above: Find opportunities to focus on each half of the couple, as well as capturing lots of shots of them together. This pose is great for women who are less confident in front of the camera, as they are hidden behind their partner's body and therefore feel less exposed.

where there are unique and unusual backgrounds. It also gives you time to prepare a "Plan B" in case of wet weather.

BEFORE YOU START

As with teenagers and adults, many couples feel uneasy when faced with the glassy stare of the camera lens, so you will need to relax them into the process. This shoot is about them, so get to know what their relationship is like and find out what kind of images they are hoping to get.

You will need to be able to direct the couple through a series of poses, moving them close together to reduce the gap between them, and paying particular attention to the position of their hands. When faced with a camera, adults can seemingly "forget" what they normally do with their hands, and having both arms hanging loosely at their sides can look very strange. To avoid this, ask the couple to hold hands, wrap their arms around each other, or put a hand in a pocket. Explain beforehand what you are going to ask of them. For example, you might say, "You both love each

other and all you have to do today is be in love and follow some really simple directions that will get you doing all the stuff you normally do together—just with me here as well. I might ask you to look in a certain direction or put your hand in a certain place—this will just ensure that you look as relaxed as possible. During the shoot I will be focusing on different parts of you, your outfits, and your interactions, so it won't just be lots of shots of you both standing in front of different backgrounds."

Educate the couple as you go through the shoot, explaining why you are asking them to do something in order to increase their confidence in you. When you take a great shot, show them, and they will begin to trust you fully.

Above: Many couples would prefer to have their photos taken in an environment where there will be fewer onlookers. If possible, though, choose a location that also holds meaning for the couple—a favorite park, the grounds of their wedding venue, or the place where they first met, for example.

YOUR APPROACH

Remember that your approach can determine the success (or otherwise) of the shoot. This isn't a serious occasion, so if there's lots of nervous giggling then play along with it. Similarly, be prepared to match the mood of a more somber couple, so they feel that you are on their level, but keep things light-hearted so that the couple enjoy the shoot, rather than feeling tense. Limit the use of direct instructions to get expressions, such as asking your couple to smile. Forced smiles can appear fake, so some of the time you will need to tease your subjects, as you would with children.

Get excited and share that excitement so they feel it too. Tell them when the light is perfect or when you've taken an amazing shot. If they don't understand a pose, show it to them by putting yourself in the place of each partner, one at a time. If one of the couple keeps blinking, simply ask them both to close their eyes and open on the count of three, rather than saying anything that might come across as a criticism. It's your job to work with the couple to get the shots you need, and you'll have a greater chance of that happening if they feel relaxed.

LIGHT & LOCATION

Some couples may be perfectly happy having their photo taken in a busy location, but most tend to prefer going somewhere where there's less risk of an audience. Speak to the couple before the shoot to find out how they feel, and whether there's a certain place that has been pivotal in their relationship. If there is, it could be an ideal location for a photo shoot.

If possible, go somewhere where you can walk along with your couple, spotting potential locations and moving to quieter areas where necessary. A large, country park, deserted beach, or picturesque riverbank is ideal.

Think about your timing, too. You will get more flattering shots if the light is soft, which occurs naturally on an overcast day. However, on sunny days you might need to use top shade, soften direct light with a diffuser, or wait until the golden hour.

Below: Prompt conversation between a couple in order to generate genuine expressions. The light and location add atmosphere to this shot, but it's the woman's wide smile that makes it.

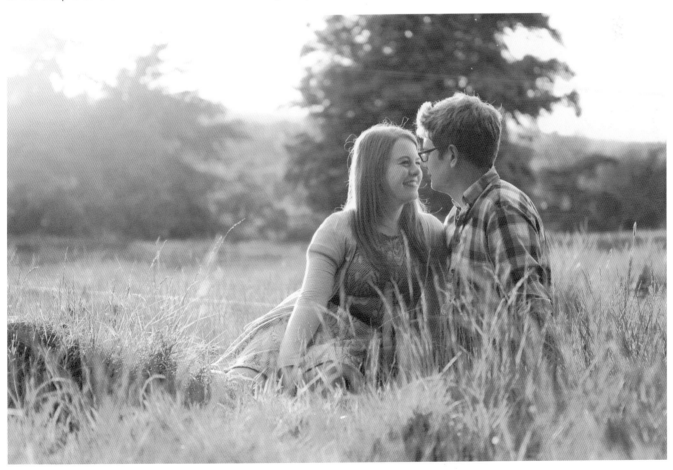

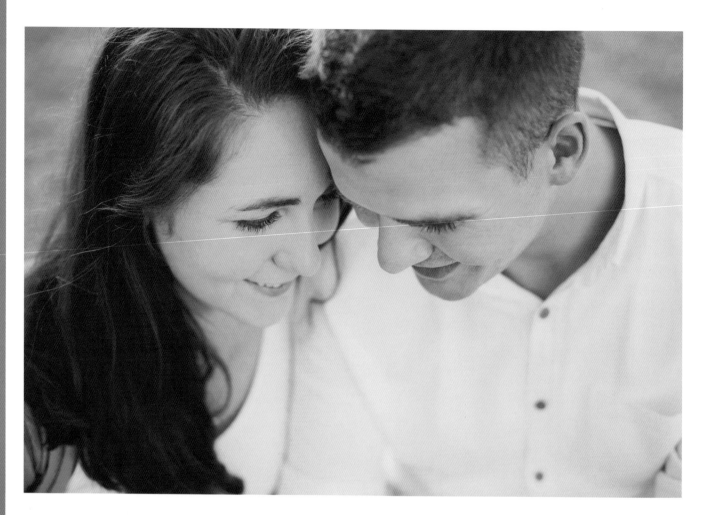

PROMPTING INTERACTION

Just as you would when photographing teenagers and adults, you need to keep a conversation going in order to help your couple forget that they are being photographed. Use the opportunity to find out more about them, such as how long they have been together and when they met.

As you are photographing two people, you have the additional option of asking them to chat to each other. This will help create genuine expressions and can also take the pressure off you, as it will give you time to experiment with your settings. You can provide conversation prompts if your couple is especially nervous or if you want to generate a certain emotion. For example, you could ask an engaged man to tell his bride-to-be how nervous he felt when he asked her to marry him.

Above: Cropping in close to the couple creates a sense of intimacy. Focus on the couple's eyelashes for the first shot, then immediately afterward ask them to look toward the camera to create a second shot with a completely different feel.

There will also be times when you want to make the couple laugh. One technique is to ask both partners to shout out the answers to fun questions about themselves at the same time, to see if their answers match. For example, ask them to both say what they think his or her favorite color/pizza topping/jungle animal is, after counting down from three. Simple games like these help them to forget any nerves.

CAPTURING A ROMANTIC MOOD

The light, location, pose, crop, and subjects' expressions will determine whether your images have an air of romance or not. Some things to try to enhance the mood include:

- Minimize any gaps between your subjects, as they will appear exaggerated in the final images.

- Use the atmospheric light of the golden hour to add warmth and ambience to your shots.

- Choose a beautiful but deserted location that implies that your couple is the only two people in the world.

- Ensure your couple is touching in some way in the majority of shots.

- Position your subjects so that their foreheads are resting together. This is a high-chemistry pose that creates a closeness you can't replicate—the couple can still make eye contact and talk, but it looks incredibly intimate.

- Crop in close, especially when capturing one or both partners looking at each other.

- Use emotive directions. For example, ask the couple to close their eyes. Then say to them, "In just three weeks' time you will be getting married..." or "You've been together for five years today..." Then ask, "Now find each other for a kiss."

- Use framing. This helps create the impression of a romantic moment captured, rather than a set-up pose. For example, photographing a kiss through foliage implies that the couple are unaware of the camera and the kiss is genuine. The foliage also adds foreground interest to the image. You can find frames almost anywhere, simply by shooting under, over, or between objects.

Tips

- With couples that have a substantial height difference, don't be tempted to position one partner (usually the man) with their head directly on top of their partner's head. This can create an unusual "totem pole" effect. Positioning them cheek-to-cheek is better.

- Although you want your couple as close together as possible, make sure they aren't squashing each other's face.

- Try to describe meaningful situations when giving instructions. For example, ask them to sit how they would if they were having a picnic, or to kiss as if they haven't seen each other for a month.

- Some poses work well standing up and sitting down, so repeat them in both positions for variety.

- As with individual teenagers and adults, the most flattering camera angle is from slightly above the couple's eye level. Stand on a chair or some steps to get shots from this angle, or seat the couple so they are lower than you.

- Continually change your camera angle, but be aware that having your subject look downward at the camera is not very flattering; double chins are emphasized and nostrils are visible. Instead, ask your subjects to look upward and/or away from the camera when using low angles, unless you are taking the shot from a distance.

- Take a variety of different shots in the same place, as they will look good displayed together on the wall or as a montage.

- Instead of constantly asking your couple to move, walk around them yourself, noting how the light and background change, and how changing your angle results in a completely different shot.

TRY THESE POSES

- Ask the couple to face each other and cuddle. This will give you an idea of how they interact with each other, and is also a quick way to move them closer together.

- Get the woman to hug the man from behind, with both their hands on his stomach. After taking a photograph of both of them, zoom in to get an individual shot of the woman, part-framed by the man. This pose can work especially well for any self-conscious larger ladies, as they are partly hidden by their partner.

- Focus on one partner and position the other so they will be in the shot, but not in focus.

- Try the "muscle cuddle." This is where the man stands face-on to the camera and puts his hands in his pockets, while the woman stands side-on to him and cuddles one of his arms. Ask the couple to look at each other, then at the camera.

- Position them so the man is cuddling the woman from behind, with her back touching his chest. Place the couple's hands on the woman's hips rather than her stomach, as having their hands on her stomach can imply that the woman is pregnant.

Above: Take shots from both partner's vantage points, to focus on each individual while keeping their other half visible in the frame. This allows you to fully capture each person's expression while they are looking directly at the man or woman they have fallen in love with.

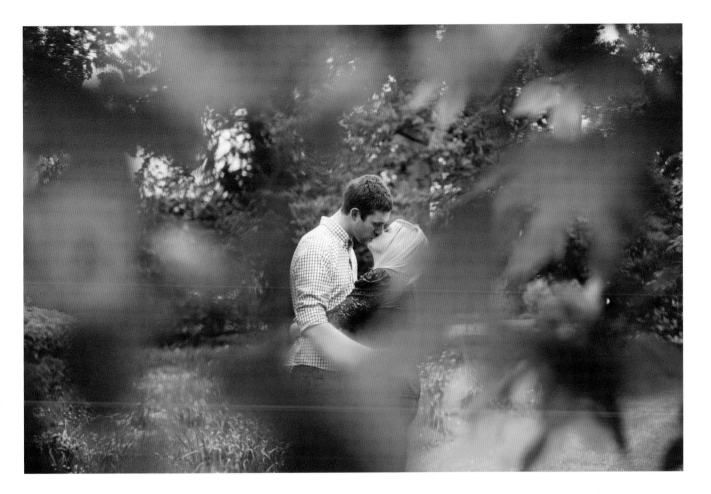

- Take shots from each person's perspective, so you can capture their partner looking lovingly into their eyes.

- Ask the couple to walk slowly toward you along a path, chatting to each other in order to make it look natural. Also try taking a shot from behind, as they walk away from you.

- Seat the couple side by side. Ask them to lean toward each other and take a shot of them looking downward, then another with them looking up at the camera. As they are looking away from the camera in the first instance, this takes the pressure off you, allowing you to get your settings right while also making them feel more relaxed as they are less aware of the camera's presence.

Above: Shoot through foliage to create the impression of a secret kiss that has been captured, rather than staged. Aim your camera through a gap between leaves, flowers, or tall grass to achieve this effect, making sure the faces of your couple aren't obscured.

- If the couple is willing, try some more adventurous shots, such as giving each other a piggy back or jumping off a step together.

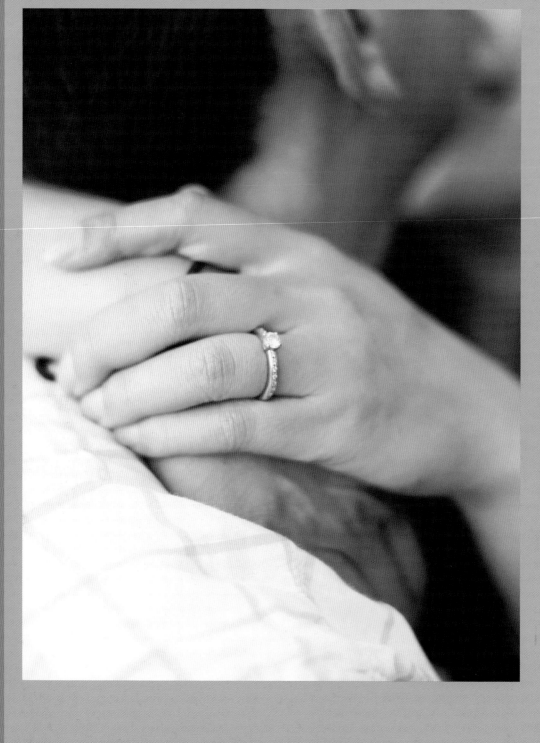

Left: Cropping in tightly focuses on the commitment that this couple has made to each other. It is the kind of shot that would work well in a montage, alongside other shots of the couple taken in the same lighting conditions.

REVISION

- Get to know your couple and help to overcome any nerves they might be feeling by reassuring them that you will do everything you can to photograph them looking their best.

- Plan where you will hold the shoot beforehand, considering the lighting conditions, which locations might make good backgrounds, and whether there is anywhere that holds particular meaning for the couple you are photographing.

- Chat to the couple, or ask them to talk to each other. Avoid silence as it can make people feel nervous.

- Keep your couple close together in the majority of shots, whether that's holding hands, hugging, or touching foreheads.

- Shoot through foliage to frame your couple and give the impression of a candid moment caught by a photographer who was in the right place at the right time, rather than a staged moment.

- For each pose, circle around the couple, taking a range of shots from different angles. As you move, the lighting and background will change, and you can also zoom or crop so the shots look very different.

- Make sure you include shots taken from slightly above the couple's eye level, as this is one of the most flattering camera angles.

COMPOSITION

Aim: Experiment with 12 compositional techniques on a couple shoot.

Learning objective: Understand how composition can improve the impact of your images.

Brief: Find a couple who are happy to pose for you—as adults are able to follow direction, you will have more scope with this age group to focus on creating images with strong compositions. Head out with the couple to some locations where you can try out the 12 different compositional techniques listed below. Before taking each shot, consider whether a portrait or landscape orientation would work best—then try both to review and compare later. Think carefully about how you place the subjects within the frame and experiment with the amount of space you leave around the couple and their position, whether central or off-center.

1 **Rule of thirds:** Take a shot of the couple where a key element of the image is positioned on one of the key areas of the frame according to the rule of thirds.

2 **Balance:** take an image that has symmetry, with equal visual weight on both sides of the frame. Look for background elements that you can include to achieve this, such as placing the couple between two hedges or at the center of a path with foliage either side.

3 **Eye contact:** Take the same shot with and without eye contact. Ask the couple to look in the same direction for the first shot, then straight down the lens for the second.

4 **Background lines:** Find some patterned flooring such as the criss-crossing lines of a pavement or wooden decking and position your couple so you can fill the image space behind them with the pattern. Frame the shot so that the lines are parallel to the edges of the viewfinder, then take another with the background lines at a diagonal angle.

5 **Lead-in lines:** Look for a handrail, path, or other feature that you can use to lead the viewer's eye toward the couple. Change your angle to vary how much of the foreground object you include and its position in relation to the couple.

6 **Framing:** Use a framing device to shoot through, leaving it visible, but out of focus in the foreground. For example, you could take a photograph through foliage or between railings, or use one half of the couple to frame the other.

8 **Angle:** With the couple staying in the exact same spot, challenge yourself to take as many different shots as possible simply by changing your angle. Crouch down and stand up, come close and move away, and circle around them until you have exhausted all possibilities.

9 **Full length:** Position the couple in a pleasing location, with flattering light and take a full-length shot.

10 **Three-quarter length:** Ask your couple to remain in the same pose and location while you zoom or move closer to take a three-quarter length shot from the same angle.

11 **Bust shot:** Move closer still and take another shot, with the bottom of the image frame cropping into the waists of your subjects.

12 **Crop shot:** Step even closer and crop the top of the image into the foreheads of the couple, making sure to leave space in the frame for their chins and at least part of their necks.

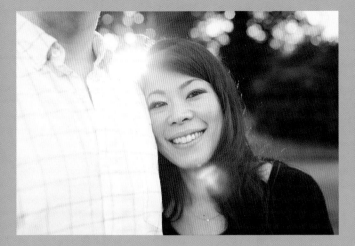

Above: The man's torso has been used as a framing device for this individual shot. I've asked the woman to lean in to his chest so they are as close together as possible, and then cropped to make sure she is the focus of the image.

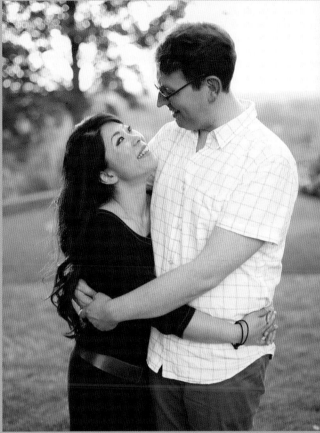

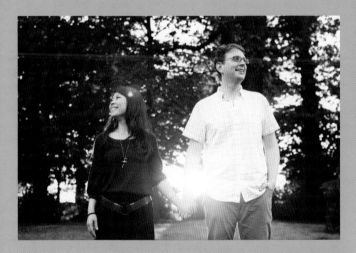

Above: For most of the shots, I wanted the couple to be as close together as possible. For this one, however, I wanted a little room between them so the sunlight created a flare where their hands met. As I needed a low angle to get the light in the right position, I asked them to look upward and away from each other, as looking downward can be unflattering.

Above: This image demonstrates the rule of thirds. Each person is positioned on one of the imaginary vertical lines, while, the woman's face is roughly placed at one of the intersections where the upper horizontal and left vertical lines meet.

TIPS

- If possible, scout out potential locations before your shoot, and have an idea in mind of the type of shot you want to return and do at each place.

- Bear in mind that your couple may be nervous about being photographed. Constantly interact with them (or prompt interaction between them) and reassure them that they are doing well.

- Remember that shorter focal lengths distort perspective and can be unflattering. Where possible, use a focal length of between 50–80mm for optimum results.

ANALYSIS

Working with a couple means there's more to pay attention to when you shoot, with two sets of limbs, two facial expressions, and so on. Take this opportunity to assess your images and see which compositions work best—for those you are less keen on, try cropping them in your image-editing software to improve the composition.

1 Look for any spaces between the couple. Gaps appear exaggerated in photos, so encourage your couple to move closer...and then closer again.

2 Don't let your images become repetitive: your couple doesn't want lots of bust shots taken in each of the locations you visit. Constantly change your angle, the amount of the couple you include in the shot, and the couple's pose.

3 Do your couple look relaxed in the images? Check for awkward-looking embraces, uneasy expressions, and hands dangling limply—one hand dangling is fine, but put at least one in a pocket, on a hip, or around the person's partner.

Above: Check each image on the back of your camera after taking it, as it's quicker and easier to take another shot now rather than edit later. Here, the angle of the woman's nose meant it was not visible, which looks a little strange—a slight adjustment to the pose would have easily fixed this.

Above: Sometimes poses can appear a little unnatural, as is the case with this embrace. When posing your couple, encourage them to follow your instructions in a way that feels comfortable and natural to them, then tidy up any limbs that look out of place.

REFINE YOUR TECHNIQUE

- Aspire to create a portrait that has a backdrop worthy of being an image in its own right. Seek out amazing locations and place your couple within them when the light is at its most atmospheric.

- One way of creating romance is to shoot your couple in a deserted location, as if they are the only people in the world. For a challenging contrast, you could place your couple in a bustling area, making sure only they are sharply focused. Use a tripod and a slow shutter speed so everyone else is blurred while your couple stays still.

Above: Find stunning locations and position your couple in them. The couple is still the focus of this shot, but the space around them makes it different to all the other images in the set.

- Shoot your couple in silhouette. Position them somewhere open, where the sky is fully visible behind them, and expose the image for the sky to render the couple as black shapes in the foreground.

Above: Expose for the sky to capture stunning silhouettes, with the couple and foreground beautifully rim lit. Use your camera's Live View mode (if it has one)—you should never look directly at the sun, especially through a camera lens.

FAMILIES

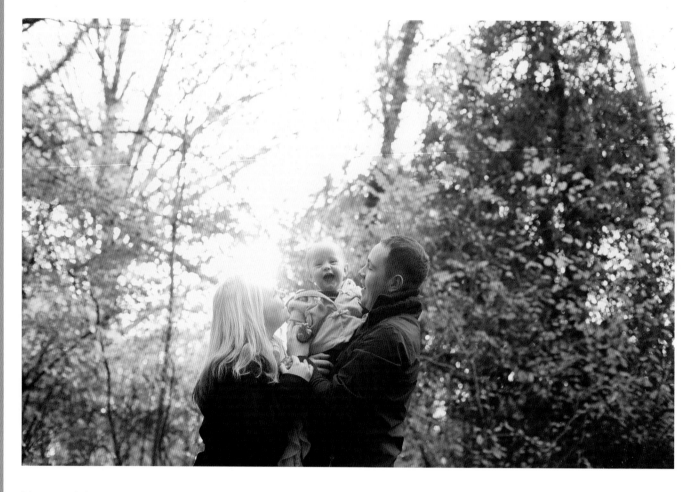

Moms and dads are usually hidden behind the camera, busily taking photos of their children. It's a rare treat to have a shot of everyone together, but also a challenge for the photographer—you will need to pose people of different heights and interact well with a range of ages to get high-impact family portraits.

YOUR APPROACH

Pressure affects people's behavior—parents start to snap or plead, while children sulk or cry. The atmosphere changes and you'll find yourself fighting your way through the shoot. It is far better to win everyone over and keep the mood

Above: Gone are the days of matching T-shirts, taut smiles, and clean, white backgrounds: contemporary family photography is all about being relaxed and authentic.

fun and light-hearted, so the smiles you get are genuine. Keep your demeanor playful throughout and be prepared to be silly, but always stay in control. You will need to guide everyone through the shoot in order to get the shots you want—remember that parents aren't necessarily used to being in front of the camera, so are likely to feel outside of their comfort zone.

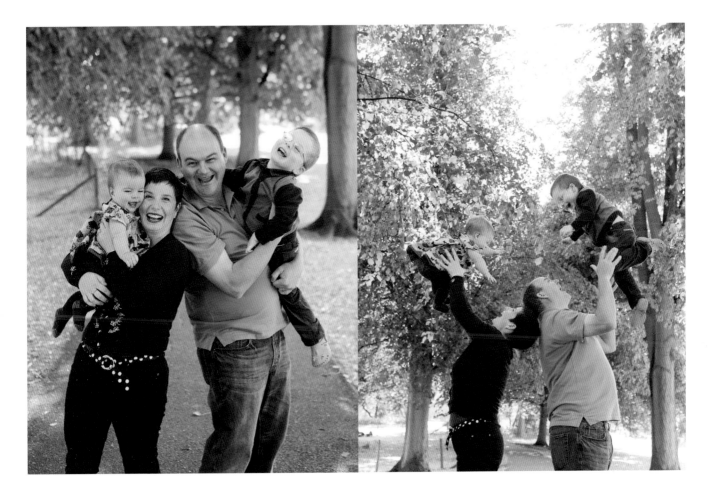

MANAGING EXPECTATIONS

A family won't laugh non-stop for the whole time you are with them. Instead, alternate between short bursts of fun activities and regular breaks. An activity could include having everybody run then stopping at an agreed point, getting the parents to throw the children in the air, or playing a game indoors, for example. However, each activity should only last a few minutes, so nobody gets a chance to become bored.

Then, either move swiftly on to the next activity, or take a break so children can have a drink or some food and change clothes if necessary. Aim to take a mixture of static

Above: These two shots were taken within a few minutes of each other. For the left one, the parents spun around in circles holding a child each, and then stopped and quickly moved close together. For the right shot, the parents stood back to back and threw the children into the air.

shots to capture how everyone looks, and "action" shots to record interactions and personality. Take time to talk everything through with the parents in advance so they understand what will happen and can let you know specific shots and combinations they would like to have.

BEFORE YOU START

It is essential that you get to know everyone before you get your camera out. With children, use the skills outlined in earlier chapters to make sure your first interaction is a positive one, and they aren't wary of you.

As you are working with multiple people, check that the clothes worn by the family members complement each other in terms of color. Ensure that no-one's outfit clashes with the others, or dominates—if everyone is wearing pale colors except one person who is in a bright red top, for example, the eye will always be drawn to the red top.

Think carefully about the possible locations, and be aware that lighting will affect your location choice, and vice versa. If you're shooting indoors, which room has the most natural light? Is that room big enough to photograph the whole family in? If you are shooting outside, make sure that

Above: Starting your shoot in and around the family home means that everyone will feel more relaxed as it is an environment they are familiar with. This shot was taken with the front door open (behind the camera), in order to flood the hallway with light.

bright sunlight isn't making your subjects squint—a diffuser is unlikely to help when you are photographing a whole family, so look for top shade to soften the light.

MIND THE GAPS

It is a good idea to remove any height differences when you photograph the family, so that everyone's faces are close together. You can achieve this by using one of the following techniques:

- Ask parents to sit, and stand the children next to them.

- Get everyone to lie on their stomachs on the floor.

- Have the parents carry the children.

- If there are spaces between family members, ask them to lean in closer to each other, or tilt their heads toward the center of the group.

Above: For most shots you will want to bring everyone's faces to the same level. For this image, the baby is sat on the bed while mom and dad are kneeling on the floor behind.

- Get small children to sit on dad's shoulders or get a piggyback from mom.

- Use steps in the garden to position people, seating the smallest family members slightly higher up.

You will also need to have the family's faces at the same distance from the camera, in order to ensure that everyone's eyes are sharp, particularly when using a wide aperture. Ask them to imagine there's a pane of glass in front of them, and explain that you need everyone's nose pressed up against it.

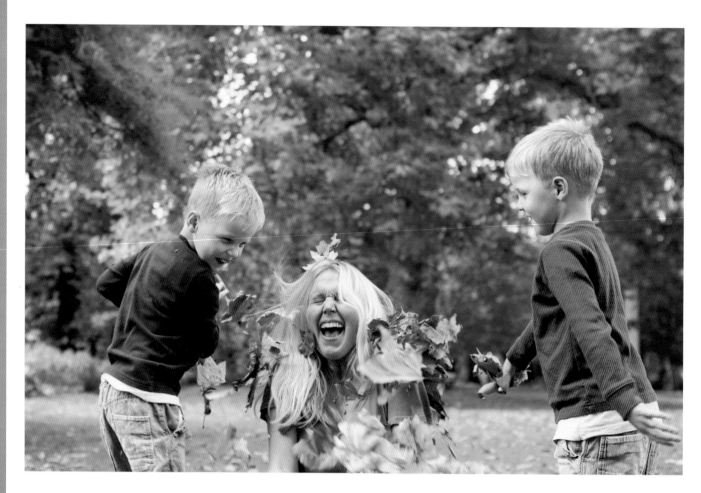

BUILDING MOMENTUM

Interactions will get the family even closer together and produce those expressions you want to capture. Try these top tips to get started:

- Tell the family to look at each other; this usually makes everyone laugh.

- Ask your subjects to rub noses.

- Tell the parents to tickle the children, or vice versa.

- Ask the kids to cuddle mom and dad.

- Get everyone to stand up, hold hands, and run or skip toward you. Holding hands helps to keep everyone on

Above: Find ways for the family to have fun and then capture the interactions. Not all images need to show everyone smiling and looking at the camera—it can be more powerful when they are looking at each other. The energy and expressions in this shot reveal a more playful side to the family.

the same focusing plane so all faces are sharp. You might need to choose a faster shutter speed and shoot continuously to keep up with the action.

- With toddlers, get the parents to hold one hand each and then swing the child into the air. Make sure you maximize the toddler's anticipation and ensure you capture the moment by counting down beforehand.

- Have the parents walk away and run back, holding the children and stopping at an agreed point. Kids love being

held by their parents as they run, and you will be able to pre-focus on the area where they will stop so you can capture everyone's smiles.

- Ask one parent to hold the child, spin around, and then stop when they are side-on to the camera. Get the other parent to step in close as they stop, and take the shot straight away.

- Get the parents to throw the kids up in the air and take the shot as they reach the highest point. The child's safety is obviously paramount here.

Tips

- Check your camera settings: you want your aperture to provide you with sufficient depth of field so that everyone's face will be in focus.

- With posed shots, position the parents first and then add the kids, so you aren't asking young children to stay still for too long.

- Start with lower energy poses and gradually increase the intensity to build the momentum and hold the interest of younger children right to the end. Keep the most fun shots until last!

Below: These parents are holding their daughter's hands to help her stand, but that also links everyone together. At this age, singing a song or playing peek-a-boo can be enough to get everyone smiling naturally.

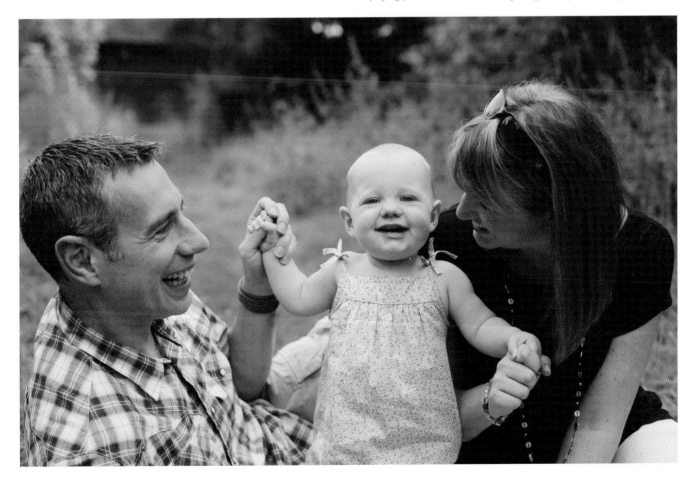

PHOTOGRAPHING YOUR OWN FAMILY

If you're photographing your own family, take the pressure off yourself. You don't need 100 perfect images on every shoot—the likelihood is that you will only upload two or three to social media sites for everyone to see and put the very best one in a frame on the wall.

You also need to swap out of mom or dad mode—you want your family to associate having photographs taken with having fun, or else it will become something they dread and need to be cajoled into.

Look out for potential locations whenever you head out as a family. Start to notice how the color and quality of the light changes throughout the day and the seasons, experimenting with the timings of your portraits.

If it's just too hard to become the fun and cheeky photographer with your own kids, call on another member of the family or a friend who is great at getting them to laugh. Ask that person to stand as close to the camera as possible, positioning their face level with the lens so it appears that the children are looking straight at the camera. Alternatively, try "shoot swaps" with another photography enthusiast. Head out together for a picnic in a meadow or a walk in the woods and take turns photographing the other family as the day unfolds.

Below: It's more difficult to create a strong composition when your subjects' faces are spaced out across the frame. Instead, ask parents to carry small children (as in this shot), or get them to crouch or sit to minimize differences in height.

One final piece of advice when it comes to taking photographs of your own family: there are some important occasions in life (such as children's birthdays) when you need to give the camera to someone else and get in the picture. Be the person holding the cake; be the proud mom or dad beaming at your son or daughter—when your child looks back at the photos, you want to visibly be part of their life and their milestones. Photographs reinforce memories, so think carefully about whether you need to be in the shot rather than taking it.

Above: When photographing members of your own, wider family, make sure everyone feels relaxed and is enjoying themselves. This will make it much easier to capture genuine smiles.

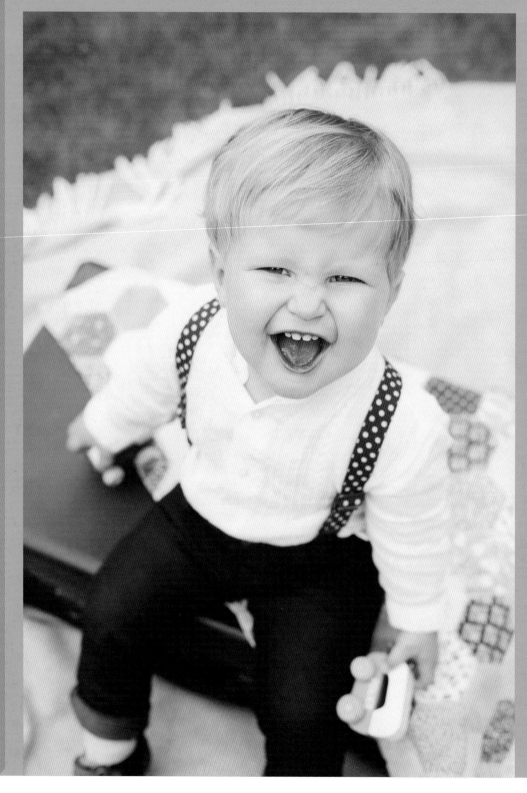

Left: I always make sure I take individual shots, so I have the maximum variety in the final set. When this boy was a baby, I photographed him lying inside a brown suitcase—now that he's bigger I got him to sit on the same suitcase to continue the story. His old-fashioned wooden toys complement his outfit and the suitcase, so I was happy to include them in the shot.

REVISION

Left: Think about how you can bring people together to interact in a way that appears natural. Although the parents were guided into place for this shot, it doesn't look "forced"—it's as if the photographer just happened to be in the right place at the right time!

- Keep the shoot light-hearted: it's much easier to get the shots you want if everyone is having fun.

- Think carefully about the lighting and the location. Have a plan for your shoot, but explore other opportunities as they arise too.

- Build rapport before you begin. Get to know the individuals in the family so that they become relaxed around you.

- Guide the family through the shoot: moms and dads are probably more used to being behind the camera, so be ready to direct them and their children to get the results you want.

- Increase momentum over the duration of the shoot: start with the more sedate shots and increase energy as the shoot progresses.

- Distances between people in photographs appear exaggerated, so close gaps wherever possible—you want everyone's faces as close together as possible, especially for the posed shots.

- Get people touching—rubbing noses, hugging, holding hands, or anything else you can think of. This type of interaction can also help to make people laugh!

- Use the moments you create to get as many different shots as possible: after a shot of one parent holding the child, zoom in to get a close-up of the child on their own, for example.

- Plan the shoot to make the most of the time you have available, but be open to opportunities for unplanned shots.

- Shoot different combinations of family members to get maximum variety in your final set: all the females together, all the males, siblings together, each child on their own, with each parent, and so on.

MANUAL MODE

Aim: Use a family photoshoot as an opportunity to experiment with Manual mode.

Learning objective: Understand how ISO, aperture, and shutter speed combine to create an exposure.

Brief: For this final project, we're encouraging you to be brave and put your camera into Manual mode. It's the best way to test your understanding of the interaction between ISO, aperture, and shutter speed and will help you gain the confidence to shoot in any situation.

To recap:

- ISO is how sensitive the camera's sensor is to light: a low ISO is less sensitive; a high ISO is more sensitive.
- Aperture is the size of the hole in the lens, which regulates the amount of light falling on the sensor. A wider aperture means more light, but less depth of field. A smaller aperture means less light, but a greater depth of field.
- Shutter speed is the length of time the camera's sensor is exposed to light. A fast shutter speed freezes motion, while a slower shutter speed can result in blurred subject movement or camera shake.

Manual mode gives you full control of all three of these key exposure elements, so you can decide your priorities (such as a wide aperture for a blurred background) and change your other settings to ensure a good exposure overall.

For this project you will need to find a family who are willing to have you accompany them on a day out to the local park, or a similar, low-pressure situation where you will have people to photograph, but the time and space to experiment with your settings. As you move between locations, test your settings until you're happy with the exposure, and then practice with people in the frame.

Don't expect to get everything right first time! This is a learning opportunity, so if an exposure isn't what you expect, think about why this might be and change your settings before trying again. Once you have figured out the correct settings for your current lighting situation, use the tips and techniques from this chapter's lesson to improve the contents of each image. Good luck!

TIPS

- Remember that your key consideration is lighting. You will need to have sufficient light to be able to experiment, so we recommend you head outdoors on a bright (but ideally overcast) day. If it's sunny, head somewhere with top shade, so that your subjects aren't squinting.

- If your exposure is too light, it is overexposed. Use a smaller aperture, a faster shutter speed, and/or a lower ISO setting to combat this.

- If the exposure is too dark, it is underexposed. A wider aperture, slower shutter speed, and/or higher ISO will fix this.

Above: There was a playhouse at the end of the family's garden, so mom and her daughter interacted with a toy tea set while I shot using a 50mm prime lens. The doors were propped open to maximize the amount of light available, but I still needed a wide aperture (f/2.5) and high ISO setting (ISO 640) to achieve a fast shutter speed of 1/250 sec.

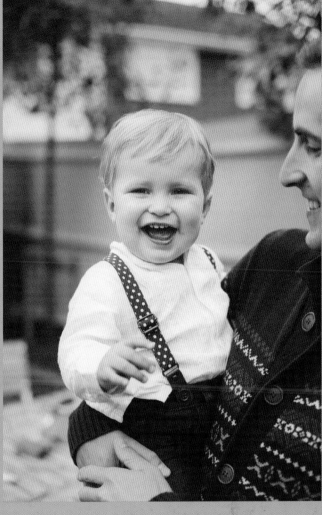

Above: Mom and dad held one child each to bring the youngsters' faces closer to their own. I asked the parents to press the children together, back to back, to minimize the gaps between everyone's bodies. The muted tones of the garden in the background add to the shot and give it a sense of place which is very personal to the family. The exposure settings were f/3.2, 1/500sec., and ISO 400.

Above: I asked dad to lift his son up, so their faces were closer together. I used dad to frame the shot, keeping the boy as the main focus. I wanted to blur the background, so set the aperture to f/2.5. Setting ISO 320 and using a shutter speed of 1/800 sec. gave me the correct exposure.

ANALYSIS

With the images downloaded to your computer, look at each shot from your family photo shoot critically. Ask yourself what works well in the photographs you like best and what would you change about the ones that you are not so pleased with—do you know how to improve them?

1 What can you do if an exposure is too dark? What about if it's too light?

2 How do changes in the light require you to adjust the exposure settings?

3 When shooting groups of people, take multiple shots in case someone blinks just as the shutter is released. It can be hard to see on the camera's screen when there are a number of people in the shot, so take more than one photo just in case.

4 Check everyone's face is in focus. You may need to change your aperture setting if this isn't the case, or move people so everyone's face is the same distance from the camera.

5 Gaps between people will appear more pronounced in photographs: check carefully before taking the shot and again on the camera's preview screen afterward. Is everybody touching? Can people be moved closer?

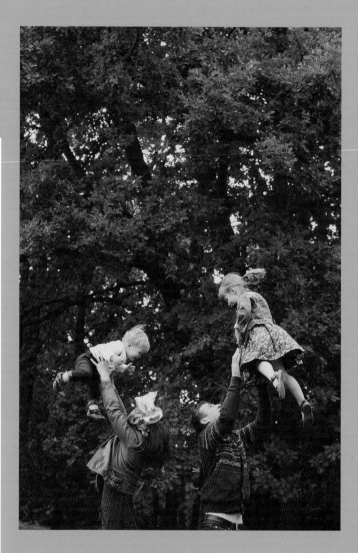

Above: Mom's scarf flew up as she threw her son into the air for this shot—a minor wardrobe malfunction! This could have been avoided by tucking the scarf in—look at the image preview on the back of the camera to check for things like this.

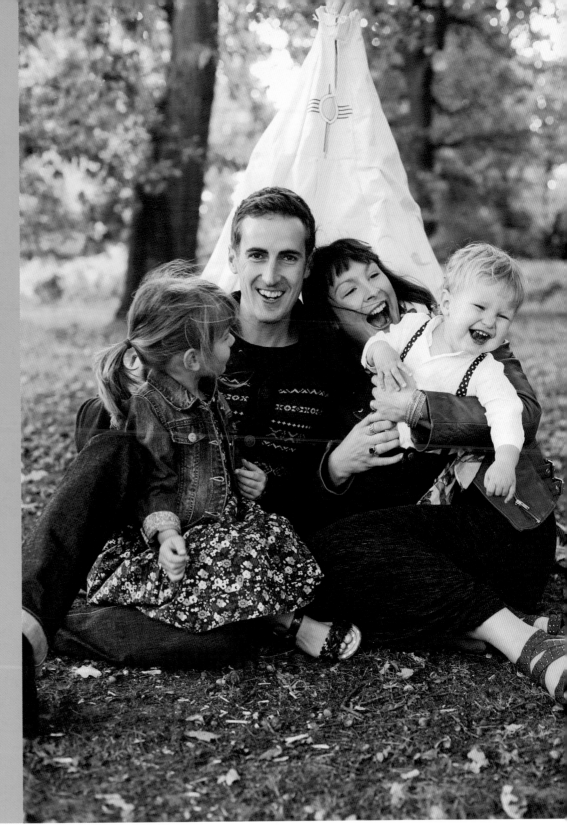

Right: The parents were asked to tickle the children for this shot, but just as it was taken the daughter looked away. This photo could still work in a montage, next to a few others taken in the same environment, but make sure you always shoot a few frames when there's a possibility of movement. This shot could also be improved by moving dad's right foot closer to his other leg.

REFINE YOUR TECHNIQUE

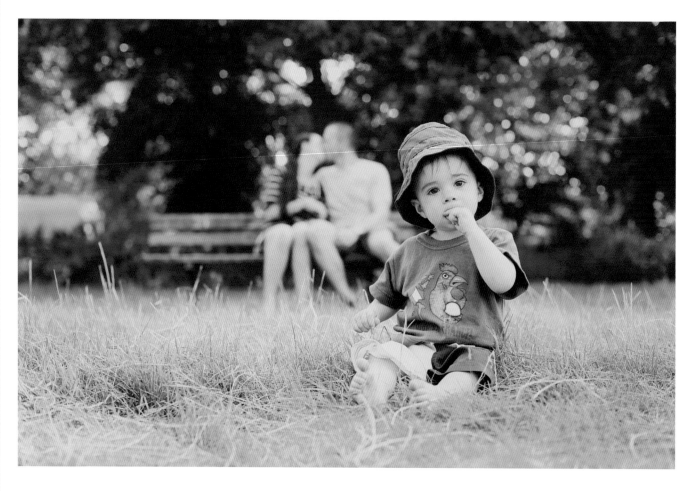

- Try split-focus shots, where some of the subjects are intentionally out of focus in the background, while the main subject is sharp.

- Think creatively about ways you can capture the family relationship without including their faces in the portrait. For example, a close-up of a child's hand on mom's pregnant belly; the dangling feet of the family as they sit on a bench in age order; or even a shot of all the family's shoes lined up in the hallway. These will add variety, context, and originality to your final set of images, complementing the full-face portraits.

Above: Use split-focus creatively for quirky images or to reassure shy parents that they won't be the main focus of the shot. In this shot, the angelic face of the son is juxtaposed with the parents having a sneaky kiss in the background.

- If you have got all the people in place, but your pictures still lack the "wow" factor, consider your lighting—it can often be the difference between a good shot and an amazing one. Time your shoot for the golden hour and see how rim-lit hair and the warm, soon-to-be-sunset color of the light can make your portraits glow.

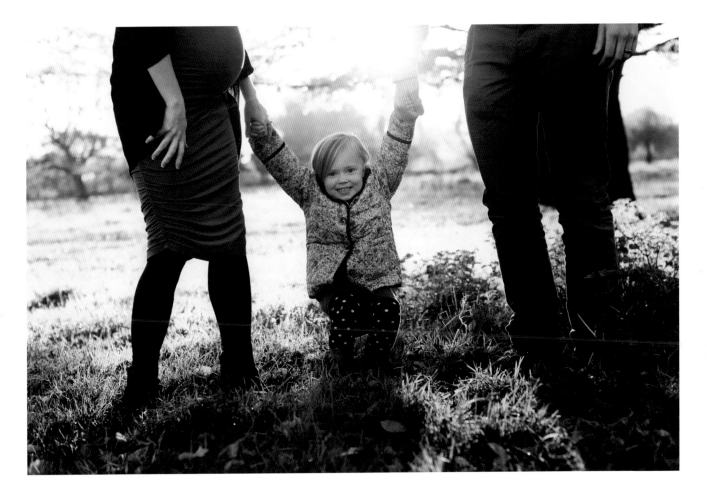

Above: Challenge yourself to show the relationship between people in families without including everyone's faces in the frame. In this shot, the daughter's small size is emphasized by contrasting her height with her parents'. She's grinning from the anticipation of being swung up into the air by mom and dad—sometimes the best shot is taken just before the fun starts!

Above: Some backgrounds are chosen to be ignored, while others are designed to complement the subjects. In this shot, the path and line of trees draws the eye firmly to the family at the center of the frame. It's a powerful example of how symmetry and lead-in lines can be used to take a shot to the next level.

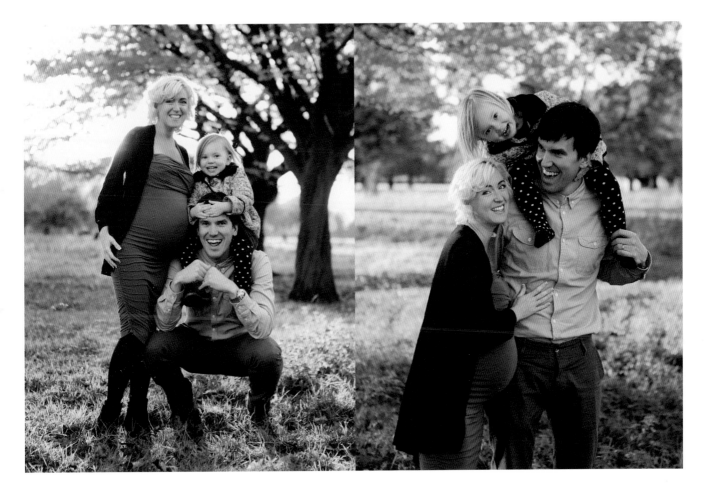

Above: The beautiful light really lifts these shots and shows one of the rare times when direct sunlight can work in portraits. These shots were taken on a chilly November day, toward the end of the afternoon, with the low sun highlighting the hair of the mom and daughter.

GLOSSARY

AEL (automatic exposure lock)
A camera control that locks in the exposure value, allowing a scene to be recomposed.

Angle of view
The area of a scene that a lens takes in, measured in degrees.

Aperture
The hole inside the lens, through which light passes to get to the sensor. Widening the size of the aperture will allow more light through, enabling a faster shutter speed, but decreasing depth of field.

Autofocus (AF)
A reliable through-the-lens focusing system allowing accurate focus without the photographer manually turning the lens.

Bracketing
Taking a series of identical pictures, changing only the exposure, usually in ⅓-, ½-, or 1-stop increments.

Camera shake
Blurring of the image caused by the photographer's movements while the exposure is being recorded. This is most likely to happen when shooting in lower light levels using a slow shutter speed. Some lenses offer image stabilization and vibration reduction features to counter this.

Catchlights
The white shapes in your subject's eyes caused by the reflection of light. Without these, a person's eyes can appear dull and lifeless.

Center-weighted metering
A metering pattern that determines the exposure by placing importance on the lightmeter reading at the center of the frame.

Contrast
The range between the highlight and shadow areas of a photo, or a marked difference in illumination between colors or adjacent areas.

Crop
The proportion of your subject and the background that you choose to include in the frame. A tight crop might exclude everything apart from one feature of your subject, such as his or her eyes.

Depth of field
The proportion of the image that is in focus, in front of and behind the primary focus area. A wider aperture will result in a shallower depth of field, making accurate focusing important.

Digital sensor
A microchip consisting of a grid of millions of light-sensitive photosites. The more photosites, the greater the number of pixels and the higher the resolution of the final image. The two most commonly used types of digital sensor are CCD (Charge-Coupled Device) and CMOS (Complementary Metal-Oxide Semi-conductor).

Distortion
A lens fault that causes what should be straight lines in an image to bow outward from the center (referred to as barrel distortion) or inward (referred to as pincushion distortion).

Dynamic range
The extremes of light and dark that the camera is able to capture in a single exposure. Very high contrast scenes, such as a bright sky behind a subject, may result in image detail being lost and recorded as areas of plain white or black instead.

Evaluative metering
A metering system where light reflected from multiple areas of the frame is used to calculate the exposure setting.

Exposure
The act of allowing light to reach the camera's sensor. A "correct" exposure is one that is as the photographer intended. Usually, this means the scene would be accurately recorded without being under- or overexposed.

Exposure compensation

The camera doesn't always choose the settings that result in the desired effect. Exposure compensation is a simple way of tweaking the settings to lighten or darken the next exposure.

Fill-in flash

Flash combined with daylight in an exposure. Used with naturally backlit or harshly side-lit or top-lit subjects to prevent silhouettes forming, or to add extra light to the shadow areas of a well-lit scene.

Focal length

The distance, usually in millimeters, from the optical center point of a lens to its focal point.

Focusing

The act of ensuring that the desired part of the image is sharp. With portrait photography, this is usually the subject's eyes.

f/stop

Number assigned to a particular lens aperture. Wide apertures are denoted by small numbers (such as f/1.8 and f/2.8), while small apertures are denoted by large numbers (such as f/16 and f/22).

Highlights

The brightest part of an image.

Histogram

A visual graph showing the number of pixels at each brightness level in an image. If the pixels are stacked up at either end of the graph, this indicates that the contrast of light and dark tones exceeds the camera's dynamic range, and detail will be lost in some areas of the image.

Hotshoe

An accessory shoe with electrical contacts that allows synchronization between a camera and a flash.

Incident-light reading

Meter reading based on the light falling onto the subject.

ISO

ISO is the measure of the camera sensor's sensitivity to light. A higher number (such as 800 or 1600) indicates greater sensitivity to light than a lower number (such as 100 or 200).

JPEG (Joint Photographic Experts Group)

JPEG compression can reduce file sizes to about 5% of their original size, but uses a lossy compression system that degrades image quality.

Megapixel

One million pixels is equal to one megapixel.

Memory card

A removable storage device for digital cameras.

Metering

The built-in system used by a camera to measure the light reflected off the subject to determine the exposure.

Mirrorless

Common name given to a camera that doesn't have a reflex mirror (see SLR). The photographer views a live image streamed from the digital sensor to an LCD screen.

Noise

Random specks of colour that appear in a photo, particularly in darker areas, as a result of pixels misfiring. The higher the ISO, the greater the risk of noise.

Overexposure

A result of allowing too much light to reach the digital sensor during exposure. Typically, the highlights in an overexposed image will be burnt out to pure white and the shadows unnaturally bright.

Pixel

Short for "picture element"—the smallest bit of information in a digital photograph.

Predictive autofocus
An AF system that can continuously track a moving subject.

Raw
The file format in which the raw data from the sensor is stored without permanent alteration being made.

Red-eye reduction
A system that causes the pupils of a subject's eyes to shrink, by shining a light prior to taking the main picture.

Remote switch
A device used to trigger the shutter of the camera from a distance, to help minimize camera shake. Also referred to as a "cable release" or "remote release."

Resolution
The number of pixels used to capture or display a photo.

RGB (red, green, blue)
Computers and other digital devices understand color information as combinations of red, green, and blue.

Rule of thirds
A rule of composition that places the key elements of a picture at points along imagined lines that divide the frame into thirds, both vertically and horizontally.

Shadows
The darkest part of an image.

Shutter
The mechanism that controls the amount of light reaching the sensor, by opening and closing.

Shutter speed
The length of time that the camera's shutter is open for, allowing light to reach the sensor. A slow shutter speed allows more light in, but increases the risk of camera shake. A faster shutter speed freezes motion and decreases the risk of camera shake.

SLR
A contraction of Single Lens Reflex. Describes a camera that allows a photographer to see the image projected through the lens by directing the image to the viewfinder using a reflex mirror.

Spot metering
A metering pattern that places importance on the intensity of light reflected by a very small portion of the scene, either at the center of the frame or linked to a focus point.

Telephoto
A lens with a large focal length and a narrow angle of view.

TIFF (Tagged Image File Format)
A universal file format supported by virtually all relevant software applications. TIFFs are uncompressed digital files.

Underexposure
The result of allowing too little light to reach the digital sensor during exposure. Typically, the highlights in an underexposed image will be muddy and the shadows dense and lacking in detail.

Viewfinder
The camera's eyepiece, which you look through to frame your image.

White balance
Different light sources contain subtle color tints (called "temperatures"), which are more noticeable to the camera than to the human eye. Your camera's white balance corrects these tints so the final image doesn't have an unexpected color cast.

Wide-angle lens
A lens with a short focal length and, consequently, a wide angle of view.

Zoom
A lens with a variable focal length.

USEFUL WEB SITES

AUTHORS
Hannah MacGregor www.funkyphotographers.co.uk
Sarah Plater www.sarah-plater.co.uk

GENERAL
Digital Photography Review www.dpreview.com

PHOTOGRAPHIC EQUIPMENT
Canon www.canon.com
FujiFilm www.fujifilm.com
Nikon www.nikon.com
Olympus www.olympus-global.com
Panasonic www.panasonic.net
Ricoh/Pentax www.ricoh-imaging.com
Sigma www.sigma-photo.com
Sony www.sony.com
Tamron www.tamron.com
Tokina www.tokinalens.com

PHOTOGRAPHY PUBLICATIONS
AE Publications www.ammonitepress.com
Photographer's Institute Press www.pipress.com
Black & White/Outdoor Photography magazine
www.thegmcgroup.com

PRINTING
Epson www.epson.com
Hahnemühle www.hahnemuehle.de
Harman www.harman-inkjet.com
HP www.hp.com
Ilford www.ilford.com
Kodak www.kodak.com
Lexmark www.lexmark.com
Lyson www.lyson.com
Marrut www.marrutt.com

SOFTWARE & ACTIONS
Adobe www.adobe.com
AlienSkin www.alienskin.com
Corel www.corel.com
DxO www.dxo.com
Florabella Collection www.florabellacollection.com
Gimp www.gimp.org
Greater Than Gatsby www.greaterthangatsby.com
iPiccy www.ipiccy.com
MCP Actions www.mcpactions.com
PhotoPills www.photopills.com
PicMonkey www.picmonkey.com

TUTORIALS
Creative Live www.creativelive.com
SLR Lounge www.slrlounge.com

INDEX

ACKNOWLEDGMENTS

Dedicated with love to my children and husband; thank you for your belief in me. With massive thanks to my close family, friends and all those who have been part of my journey so far with Funky Photographers. Special thanks to Abigail White for taking our head shots for this book and for your continued support.

Hannah MacGregor

Dedicated to my husband, Jon. With thanks to Matt for his support and Taryn for inspiring me to get started in photography. If you think you can, you can. If you think you can't, you can't.

Sarah Plater

AMMONITE
PRESS